MICHAEL FREEMAN
THE PHOTOGRAPHER'S [EYE]:
A GRAPHIC GUIDE

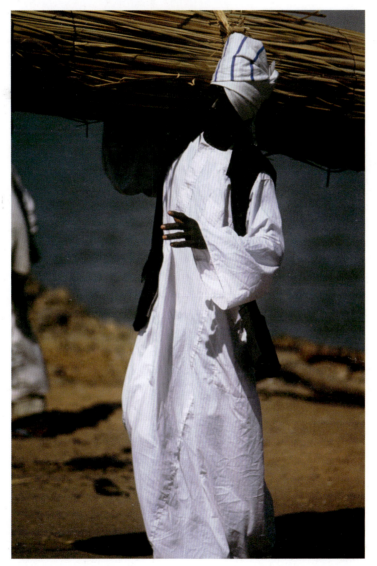

MICHAEL FREEMAN
THE PHOTOGRAPHER'S [EYE]:
A GRAPHIC GUIDE

Instantly Understand Composition & Design
for Better Digital Photos

Focal Press
Taylor & Francis Group
NEW YORK AND LONDON

First published in the USA 2013 by Focal Press

Focal Press is an imprint of the Taylor & Francis Group,
an informa business
70 Blanchard Road, Suite 402, Burlington, MA 01803, USA

This book was conceived, designed, and produced by
Ilex Press Limited, 210 High Street, Lewes, BN7 2NS, UK

Publisher: Alastair Campbell
Associate Publisher: Adam Juniper
Managing Editor: Natalia Price-Cabrera
Specialist Editor: Frank Gallaugher
Editor: Tara Gallagher
Editorial Assistant: Rachel Silverlight
Creative Director: James Hollywell
Senior Designer: Ginny Zeal
Design: Simon Goggin
Color Origination: Ivy Press Reprographics

Library of Congress Cataloging in Publication Data:

A catalog record for this book is available from the Library of
Congress.

ISBN: 978-0-240-82426-0 (pbk)
ISBN: 978-0-240-82460-4 (ebk)

Typeset in Minion Regular

CONTENTS

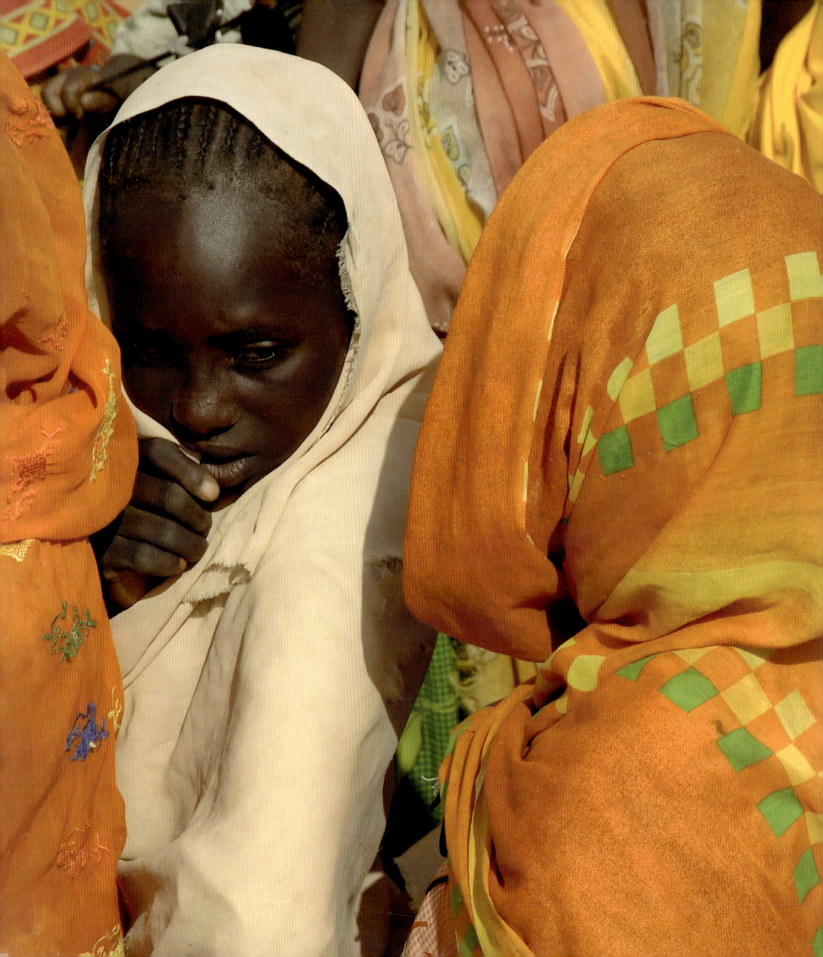

INTRODUCTION

This book takes as it's starting point my earlier *The Photographer's Eye*, which deliberately concentrated on how the image works rather than how the camera works. One of the things I realized with that book and its sequels was that often it would have been simpler in explaining a point about composition or color to have bypassed words and instead relied more on a purely visual explanation. That's the premise here. Words to a necessary minimum, with visuals carrying the story. The decision also allowed me to indulge my love of making illustrations, although you might wonder why a photographer would be illustrating when he has a camera. I can't really answer that question, but somehow, for me, the two go together. In any case, I've always thought that text and imagery gets processed by the brain in such different ways that any illustrated book demands a kind of jump in the reader's mind as the eye moves from one to the other. Here at least, we're asking for less mental jumping by keeping most of the information on the purely visual, graphic plane. Photography itself is an entirely visual experience, so any description of what went on at the time of shooting has to be reconstructed later if it's to be put into words.

What follows is very much my idea of what is important in shooting, so I take full responsibility for any omissions, which are entirely deliberate. Photography, for me, calls on three essential sets of skills, which I call technical, visual, and conceptual. They differ; they are all important, and to be a complete photographer means not only having them, but also being able to balance them. Technical skills are to do with camera handling, knowing about exposure, depth of field, processing pictures on the computer, and so on.

Almost all books and websites about photography focus on these, and they're essential—but only the beginning of the story. Visual skills are more about seeing, understanding, framing images in the viewfinder, and of course composition. This, frankly, is when photography stops being nerdy and starts to become fascinating. The third set of skills is conceptual, and the word shouldn't be daunting because it's really about having a clear idea of what you're about to shoot. Are you aiming for beauty, drama, spectacle? Or perhaps you're trying to persuade your audience of something. Or setting out to tell a story with your camera.

Because most writing about photography concentrates entirely on the technical, I've always tried to stress the other two skill sets, because they deserve much more coverage than they usually get. In this book I'm looking mainly at visual skills, though naturally they can't be completely separated from such technical matters as getting the depth of field right for what you want to show, and knowing what shutter speed will deliver the exact degree of frozen, or streaked, motion. Nor are they totally isolated from conceptual ideas such as making a point by juxtaposing two subjects.

What follows is as thorough an explanation of why and how these images work as I can manage without getting wordy. To make some sense of what is a huge subject, the book is divided into ten chapters that each concentrates on a key theme in photography, from the basic act of putting a frame around a potential subject, to working with ideas and imagination in juxtaposing and combining elements of the image.

PART 1
FRAMING

There's a subtle but important distinction between framing and, let's say, composition. Framing the shot usually comes before anything else—the first decision. Composition (or design if you like) covers the whole range of organizing the image, while framing concentrates on enclosing the scene, even before thinking about the relationship between elements inside the picture. It's no coincidence that the term comes originally from filmmaking, where a scene is enclosed (framed), after which the action plays out within it. There may not be quite this degree of separation in still photography, where the image is singular rather than multiple, but the decisions about where to cut into a landscape, figure, or object, and what to include and what to leave out, still rank as the most important in defining the shot.

EXACT

Framing can be as rigorous and precise as you have the time or energy for. The extreme is probably studio still-life photography, where there is full control and an absolute obligation to bring things into some kind of order. Here, the subject is a white cowrie shell. What could be simpler than that? The set and the lighting, too, are deliberately simple: black acrylic for the surface and a large softbox overhead. These are not throwaway, get-it-done-quickly decisions, but rather the best way of showing volume and shape. I've closed in because I want to play with the elegant curves, and because detail can open up a different world of perception. But how much of the shell to include, and where exactly to cut? How close to bring the curved outline to the frame edges, and how to divide the proportions between the shell, the black background and the red interior? The cuts and the gaps were proportionate to the angle at which the various curves of the shell interacted with the frame edges.

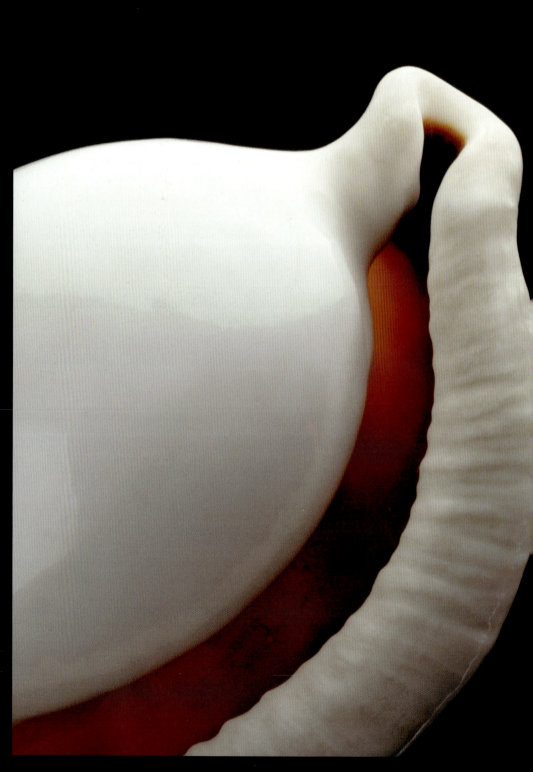

▲ Egg cowrie, 1981

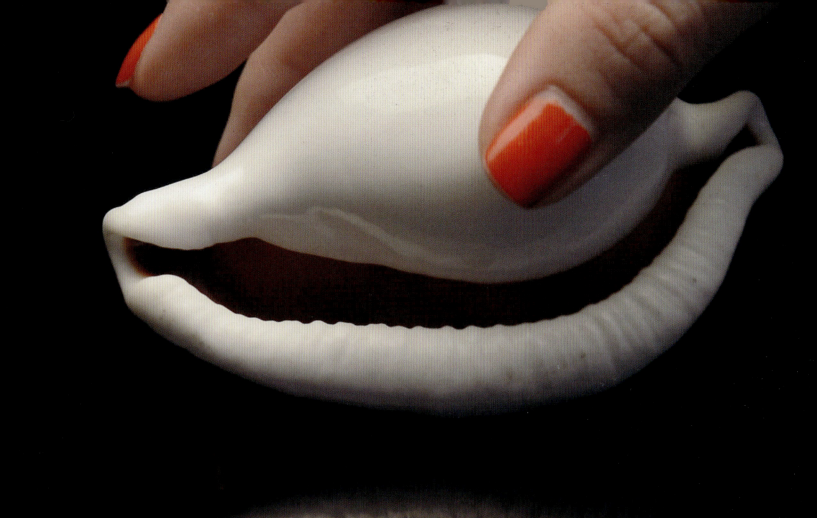

▲ Placed against black acrylic with a soft top light.

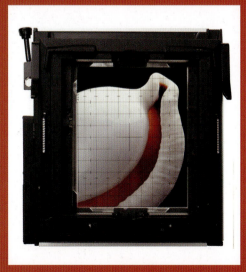

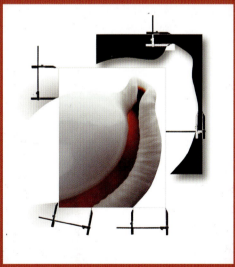

▲ Framed on the ground-glass screen of a 4x5-inch view camera.

▲ The angle of the curves cutting the frame influenced the size of the divisions.

▲ Proportions of the three colors were also taken into account.

EDGE-ALIGN

If there's a straight edge in the subject, and it's close to one edge of the frame, it suddenly acquires a new relationship. The closer you position it, the stronger this feels, like a kind of magnetism. This particular alignment, from an Irrawaddy riverboat in Burma, happens to be rectilinear and squared up, and was hard to avoid, as I was standing on the bank at one of the ferry's frequent stops (I was a passenger), looking for activity on board. The boat's various openings framed scenes of regular, semi-domestic Burmese life as families travelled for two or three days upriver. I concentrated on one woman hanging out a blanket to dry in the sun; the lighting was intense and frontal, and made me think of a frontal way of framing. The alignment was then inevitable, and the high contrast encouraged me to shave the distance between the upper left and top edges to the absolute minimum.

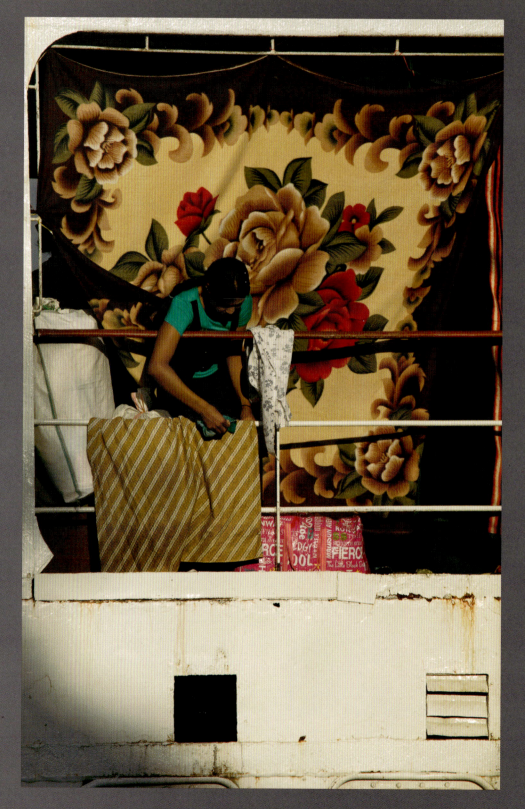

➤ Mandalay–Bhamo public boat, 2009

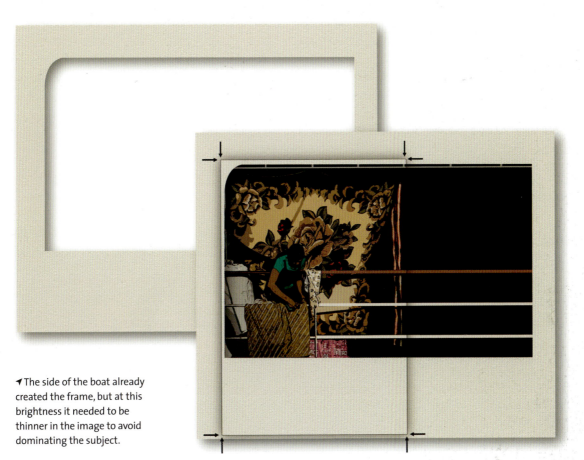

◂ The side of the boat already created the frame, but at this brightness it needed to be thinner in the image to avoid dominating the subject.

▾ The shooting sequence.

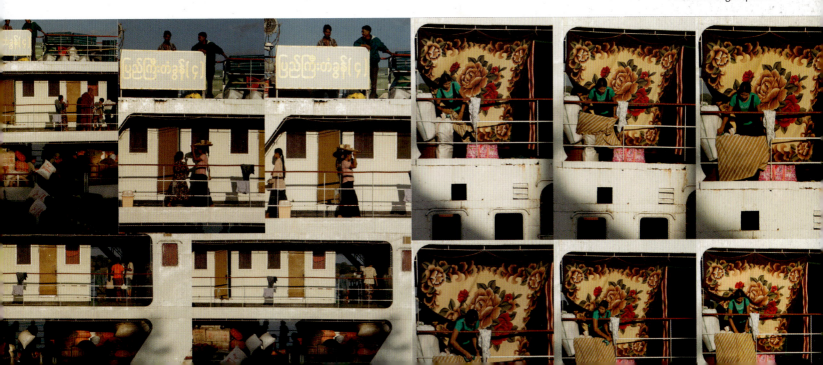

LOOSE

Loose framing doesn't (or shouldn't) mean ill-considered and sloppy. It means, in this case, not being obsessed with how things fit into the frame, or how objects intersect with the edges and corners, and not minding when the frame breaks into a person or some other unit. It's partly an attitude, and suits situations in which the action takes precedence over the finer points of the frame. Here, we're on a tea plantation in Assam, and it's harvest time. It's a wide-angle occasion (24mm throughout) not so much for pulling more of the scene into the picture, but rather for getting in close among the people and the action. The viewer's attention is going to be centered on the activity and gestures, and unlikely to be much distracted by the borders. In a busy scene like this, the edges and corners of the frame will be less noticeable. What's important is the interaction of just three elements: the woman in the foreground, the woman helping pour out the basket, and the flow of tea. The rest is secondary.

▼ Tea picking, Assam, 2009

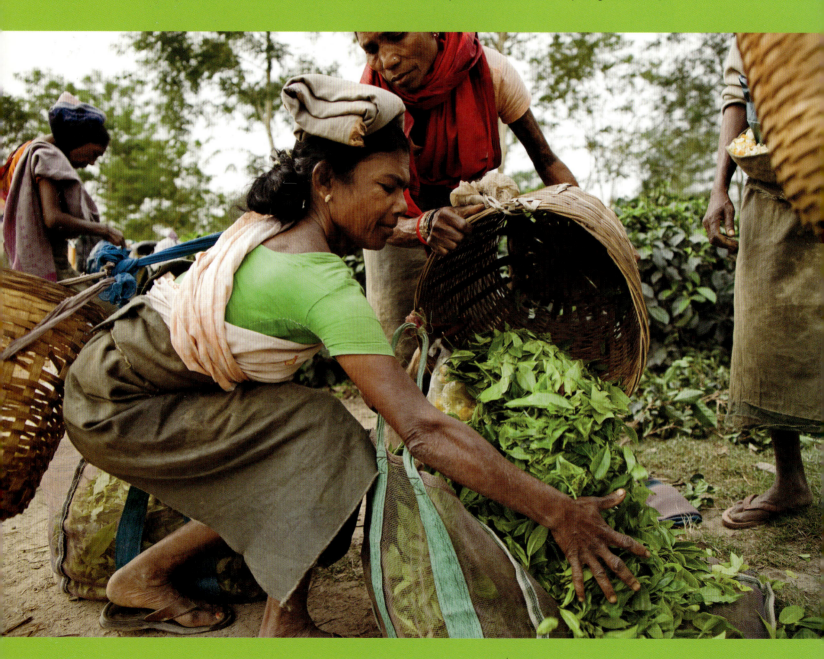

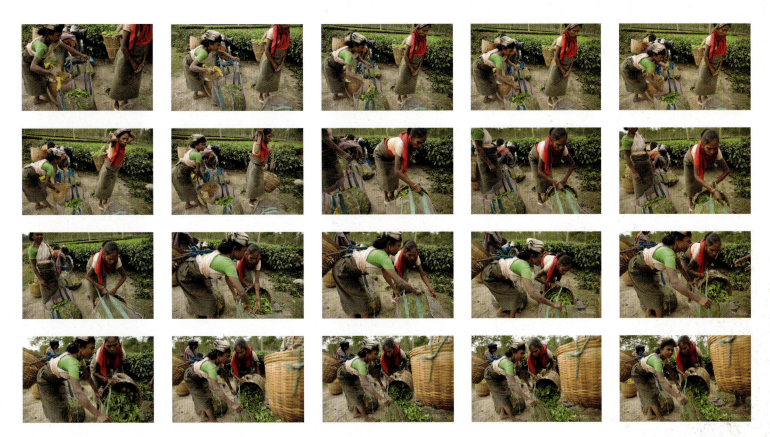

▲ The entire take, which took just under one minute.

▲◀ The shooting situation depended entirely on three units—the two women and the flow of tea leaves—and fitting them together in the frame.

FRAME-FIT

When you're looking for precision and alignment, and the shape of the subject seems similar to the picture frame—or could be made similar—there's the possibility of being clever with the edges and corners to make everything just fit. Emphasis on "just," because this is a tricky procedure. One slip and it all falls apart if anything important actually breaks out and crosses the edge. Yes, you could crop in later to make it appear to work, but that wouldn't really be the point, would it? To be satisfying and neat, the subject has to match the frame. It's even possible to waste a lot of time moving around and changing lenses to make this happen. Here in Stykkisholmur, Iceland, the neat and orderly buildings included this picket-fenced church, and I realized that there was a camera position that would deliver. The slight gap at the top, above the cross, is deliberate—any less would look too tight. It's all about order and keeping a watchful eye on every corner and edge.

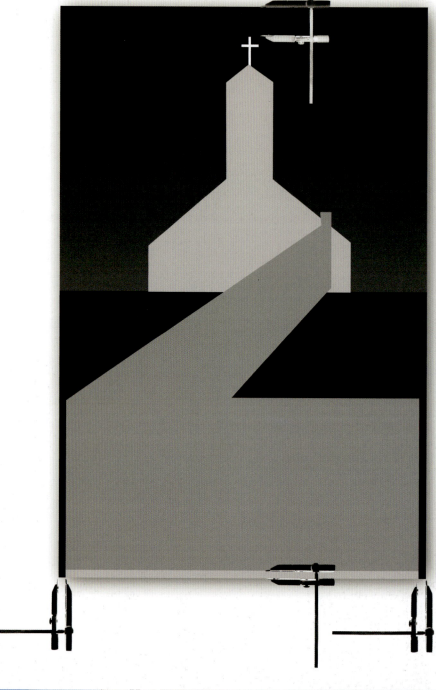

➤ The lower third of the frame has exactly equal gaps.

➤ The sequence leading up to the final frame.

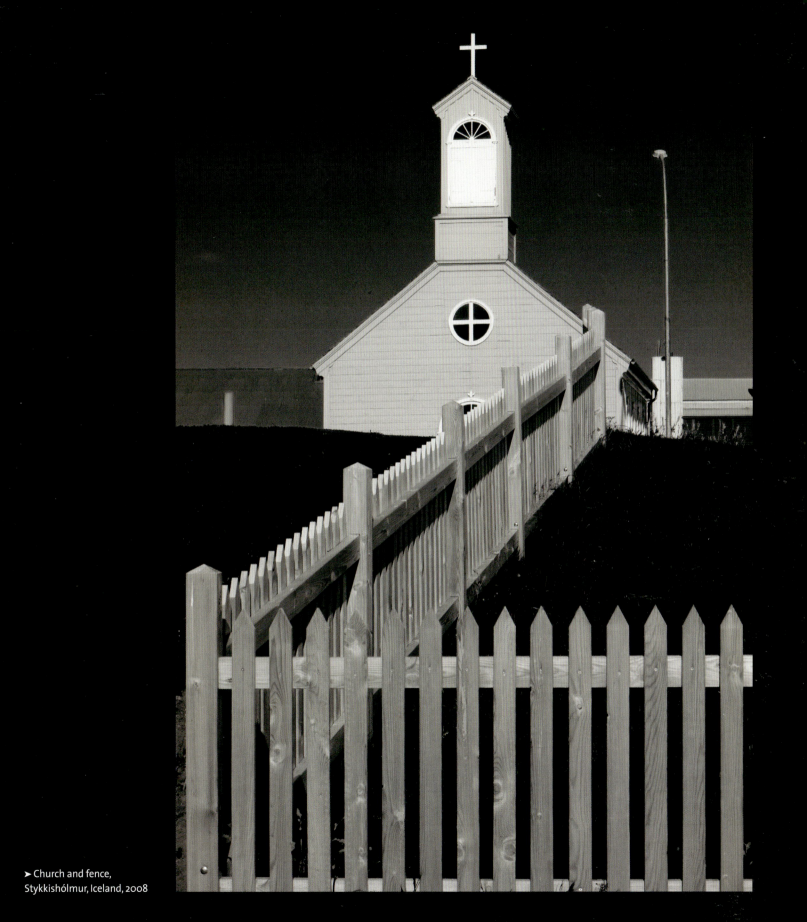

➤ Church and fence,
Stykkishólmur, Iceland, 2008

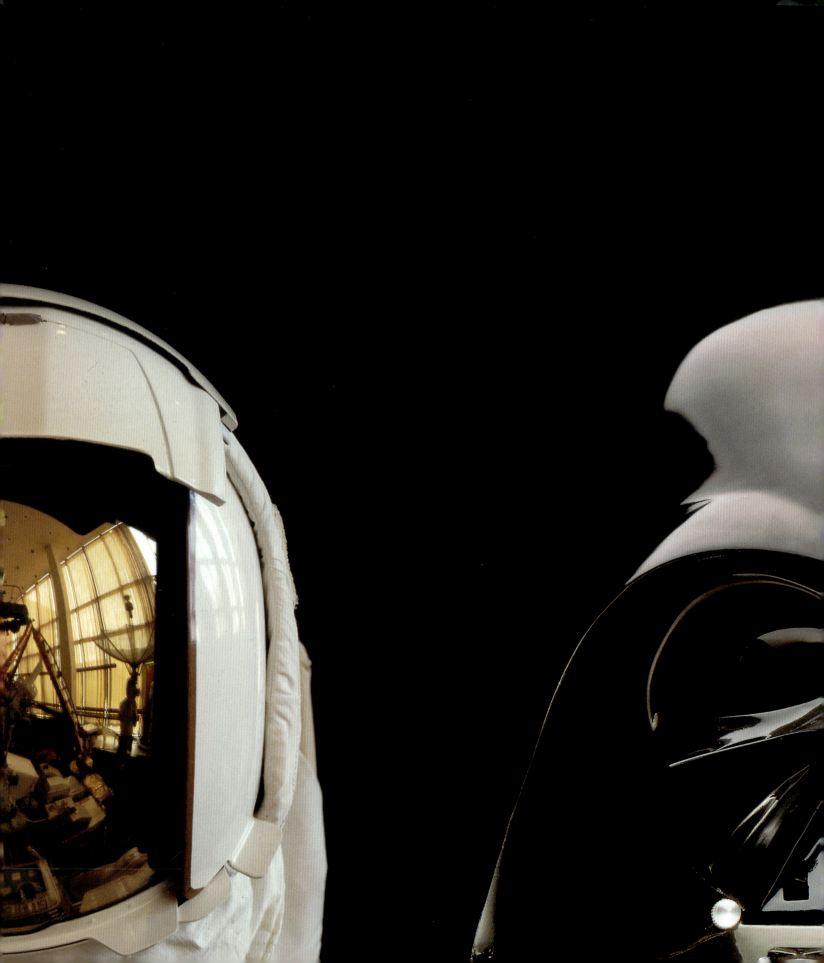

FRAME BREAK

This is the opposite of the previous image. Far from carefully fitting things inside, we carefully break them in half, and for a good reason. On separate occasions, I shot two famous space helmets: Apollo and Darth Vader (they're kept very far apart, one in Houston, the other in a secret warehouse in San Rafael), but wanted to show them together. Two alternatives are shown smaller here—simply side by side, and joined.

This framing is too wide and, well, pedestrian. Showing half of each is that much more interesting because it's not quite expected, and works perfectly well because the helmets, like faces, are virtually symmetrical. That makes the image symmetrical, but in the opposite way from the image shown under Symmetrical on page 52. In one case, the eyes move to the center; in this case, they are pulled apart.

▼▼ An alternative treatment would be to create one helmet from the pair, perhaps with opposing backgrounds to highlight the contrast. However, the difference in the height of the visor makes this less successful.

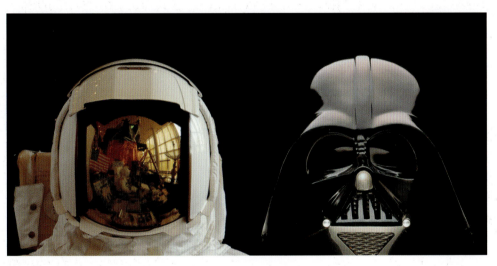

▲ Simply side by side shows more than we need to see.

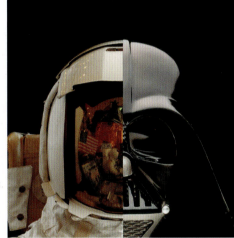

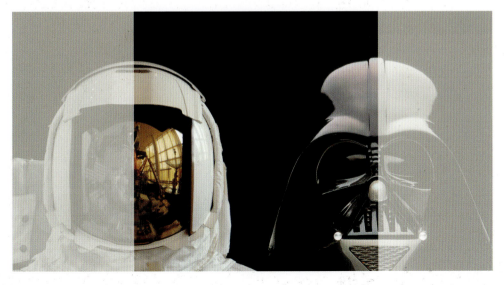

◄ Two space helmets, 2008

▲ The left-right crop divides each helmet exactly in half.

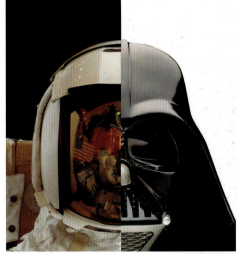

TALL

When do you rotate the camera for a vertical shot? Horizontal is the default because of the way cameras are designed to be held, but vertical offers different possibilities. This is Monument Valley, straddling Arizona and Utah, and the rock formation is Bear and Rabbit Rocks (the rabbit is a lot more obvious). There are many ways to shoot this, starting with a distant view, but the outline shapes are its most interesting feature, so pre-dawn looking east seemed a natural first shot. The group is horizontal, but the main features are vertical, so matching a vertical frame to a tall subject is one obvious approach. But if we want a sense of tallness, there's a little more to it. The Rabbit is striking, but maybe too obvious. Sunrise, however, will offer something if I can catch it right at the bottom of the V, and this means some last-minute running as I guess its upward trajectory. The sense of tallness here is stressed by the opposition of dark peak and flaring sun.

➤ Bear and Rabbit Rocks, 1979

▼ The pre-dawn vista at Monument Valley, which includes these formations.

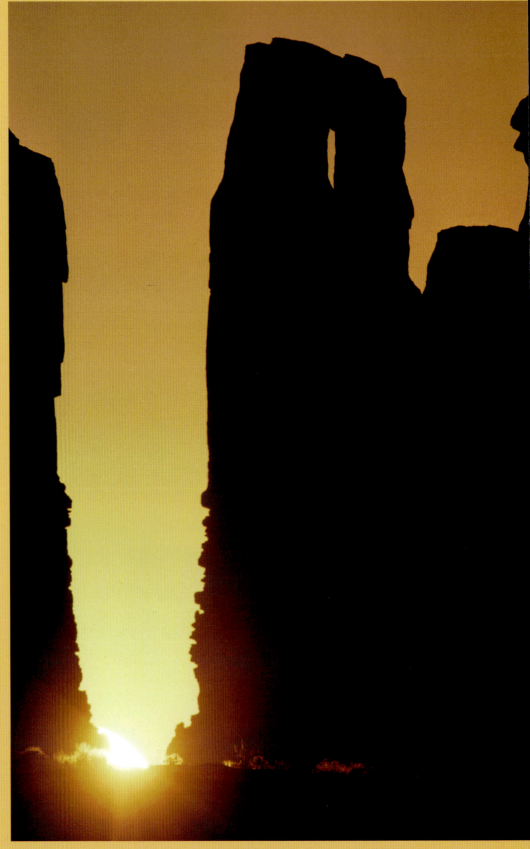

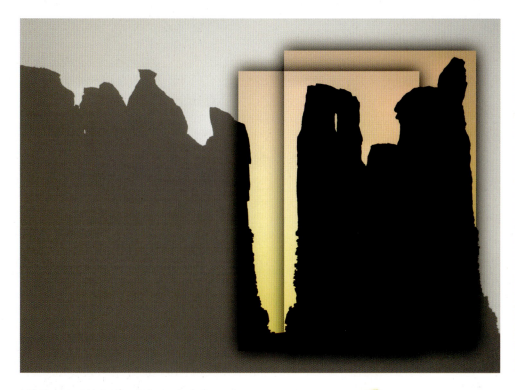

▲ The two possible 2:3 framings: one including the Rabbit, the other anticipating the sunrise.

▲ Peak and sun lie at opposite ends of a double U-curve and emphasize the vertical length (tallness) of the frame.

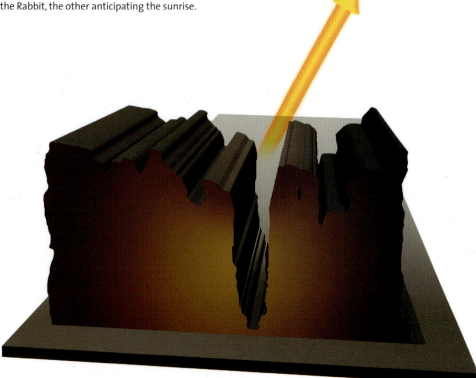

◄ The sun's trajectory needed to be exactly aligned.

SQUARE

A square format was never seen in the visual arts as a natural frame, and was used just occasionally, often to make a point about rigor and severity. The equal sides give a sense of strictness, formality, even constraint. Photography was different, because for decades there was medium-format 6x6cm film, and this pushed photographers into finding square compositions. They found that square could be good—on occasions when you want to divide things equally, to center things, when you have a uniform field or a symmetrical subject, and when, as here, you want to enclose another shape. Because the square frame has no bias and no direction, it tends to draw the eye inward. In this group shot of children in Cartagena, Colombia, the square frame encloses a triangle. Note the counter-shading at work to help define the shape—the darker edges of the group stand out against the lighter floor and wall, and the edge-lit boy on the left stands out against the dark door.

▲ A central triangle, with two outlying wedges, sits comfortably within the neutral square.

▲ The square's lack of bias—all sides equal—makes it easily divisible into equal parts, and also gives it a definite center, like a circle.

◄ Children, Cartagena, 1973

WIDE

Widescreen is spreading. In film, it means any aspect ratio wider than Academy (1.37:1), but in television and computer screens, the arrival of HDTV has made 16:9 the most popular format. And as directors of photography know, wide is a very attractive format in which to compose. Sometimes, the shapes and lines in a scene just want to take the frame wide, and one of the very good benefits of digital shooting and content-recognition software is that you can simply swing the camera to one side for another frame that will stitch seamlessly and painlessly with the first. Some cameras even have built-in panoramic stitching. This scene on a beach, on the Indonesian island of Billiton, encouraged a wide perspective with the curved canoe on its side. I worked around it, and liked the matching curve of the fisherman's cap. About halfway through (I shot for five minutes), I realized the possibility of turning this into a widescreen image, and shot quickly for a two-frame stitch. There's a set of parabolic curves here, which makes the image cohere, together with the implied curve of the out-of-frame part of the boat.

▼ Fisherman, Billiton Island, Indonesia, 2012

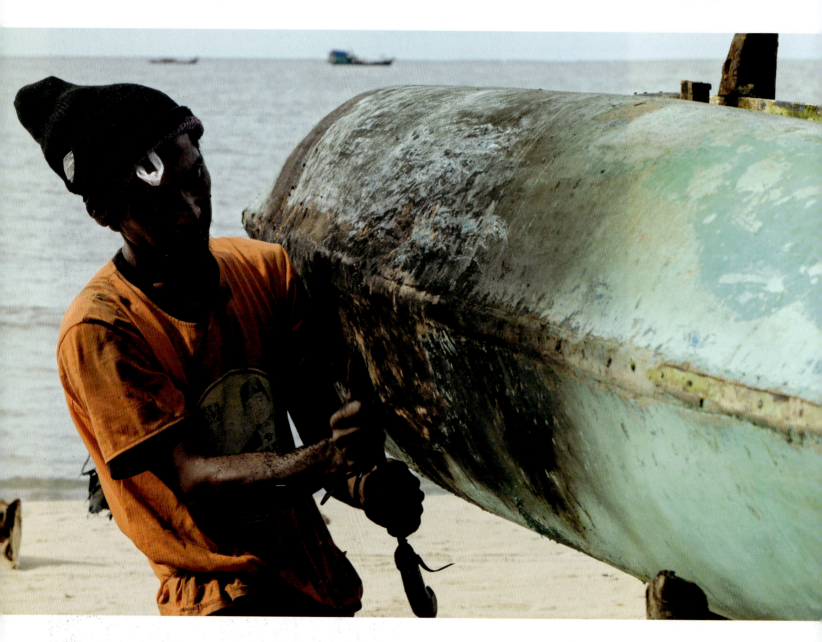

◄ The matching parabolic curves, and their assumed off-screen counterpart from the curved end of the canoe, suggest the wide frame.

▼ The shooting sequence.

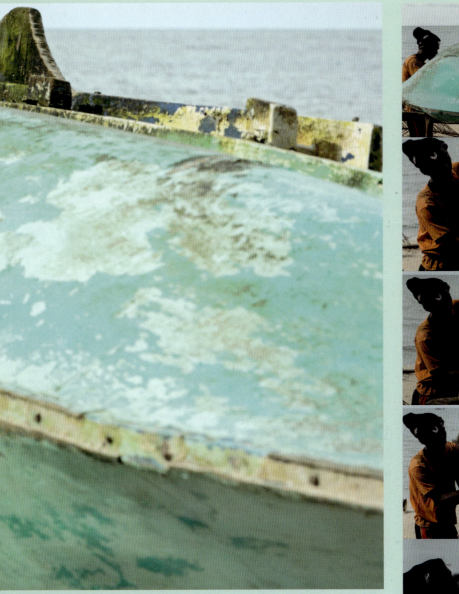

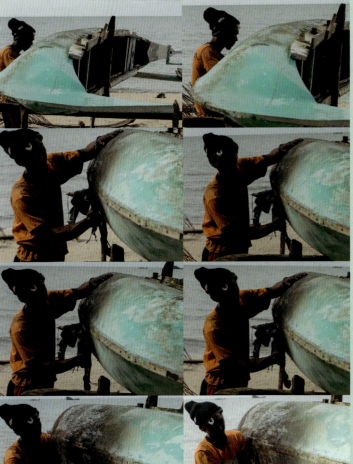

PANORAMIC

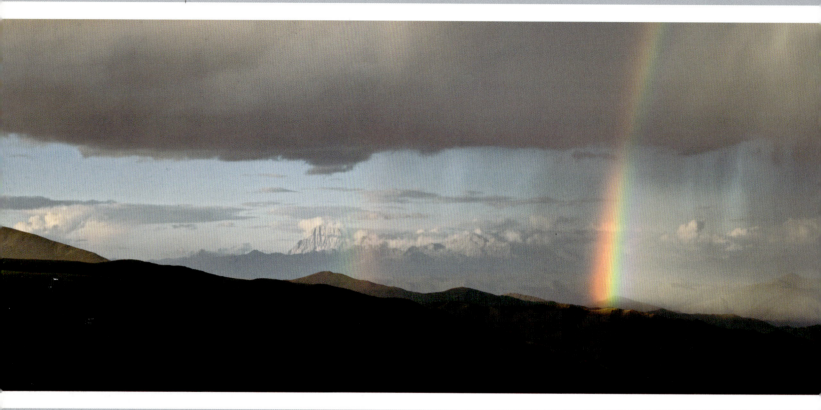

On the previous pages I used a quick two-frame pan, but you can continue panning and shooting to construct a true panorama, as wide as you like. Not all scenes deserve it, however, so the discipline in photographing panoramas is in imagining clearly how the final frame will look. This was the high grassland of western Sichuan, and a double rainbow plus Yala mountain in the far distance made the shot. Grasslands have a wide-open feeling in any case, justifying a wide panoramic treatment. Shooting the series level and consistently is important, otherwise the shot may not work at all, for the

reason shown in the illustration. If you drop even slightly from frame to frame, as can easily happen if you shoot handheld, you would need to crop so severely that you could lose the skyline. Nevertheless, as long as you pay attention to this, stitching software is now so good at content recognition that you don't need a tripod. For safety, overlap each frame by about a half. A simple way of doing this is to note some part of the view that is on the leading edge of the frame, then put it in the middle for the next shot. More important is where you stop panning and what you choose to close the frame at left and right.

▲ Yala Shan and rainbows, western Sichuan, 2009

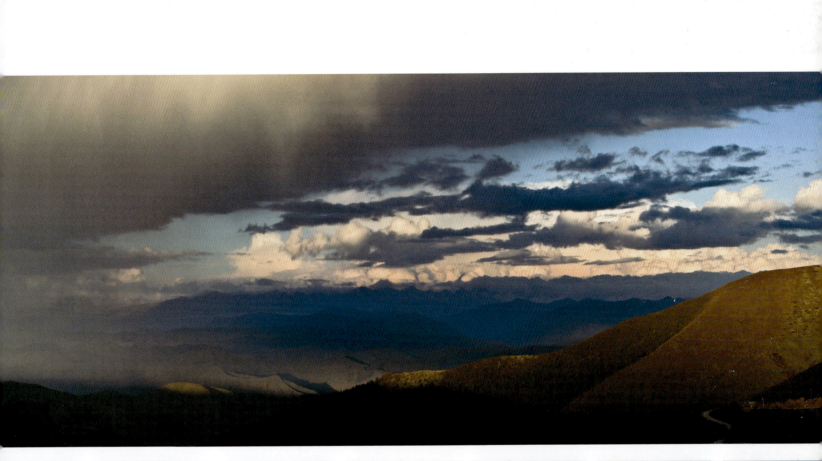

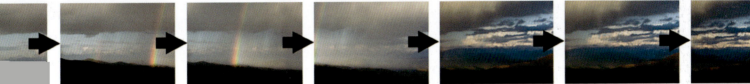

▲ The sequence of overlapping frames for stitching.

▼ The full-width stitched panorama was cropped to balance the mountain and rainbows off-centered left against the sunlit slope at right, and the area of contrasting clouds above it. Coincidentally, the main rainbow is at the Golden Ratio point.

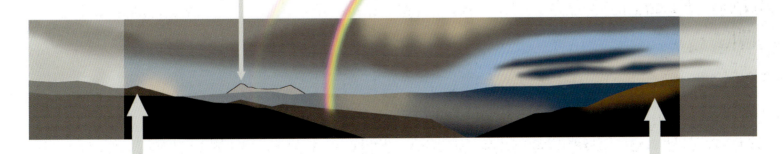

OFFSTAGE

When you frame a shot, you leave out more than you include. That's the idea, of course—establishing the photographer's view of what is going on, and no one else's. Sometimes, however, the suggestion of what might be happening out of frame can be intriguing. The conventional idea in photography—and in painting, for that matter—is to gather into the frame what we want to show. This thoroughly accepted way of doing things gives a special value to the occasional image that makes some reference to events that are deliberately off-stage. The word to stress here is *occasional*, because of the risk of being simply annoying. Here, we're on the summit of Adam's Peak in Sri Lanka, where worshippers wait during the night for—the sunrise! Nothing so special about that, maybe, but it means a lot in this place to these people. And it's better not to see the sun in the same frame, because there's that touch of mystery, a question mark. What is the man pointing at? We soon realize the answer, but for a moment it makes the image more engaging.

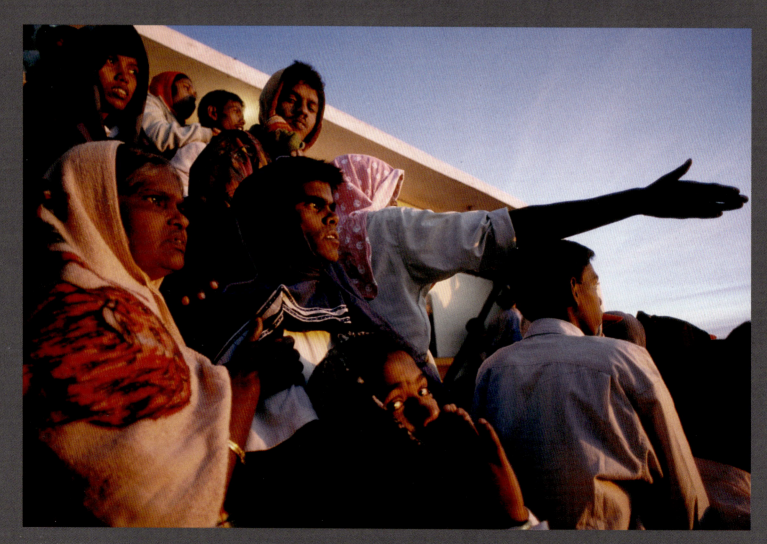

▲ Adam's Peak, Sri Lanka, 1998

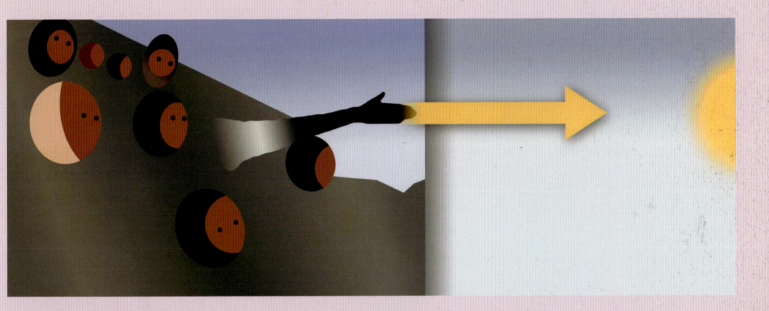

▲ The hand and turned faces (well, most of the faces) extend the sense of the image to the right.

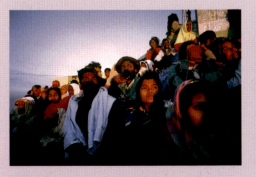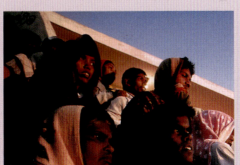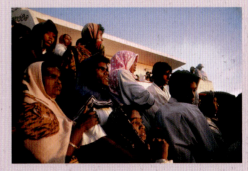

▲ The sequence, minus the pointing hand.

PART 2
PLACING

Yes, there is a difference between placing things and framing them, even though they are inseparably linked. Placement assumes two things, both quite common. One is that there is a subject that is concrete—a single, identifiable unit, rather than a concept, pattern, or some overall generality. A person, perhaps a structure, or a tight group of things. The second is that this subject is small enough in the frame that you do actually have a choice of where to put it. Given these two conditions, which are quite easily met, the decisions are generally to do with where in the rectangular frame, and how close to other things. It's no more complicated than that, but because every picture situation is unique, doing it for any one photograph can be anything but simple. Some people favor rules for doing this, but that takes all the fun and imagination out of it.

OFF-CENTER

On those occasions when you have a clear, well defined subject in a simple, even setting, you have to decide where it goes in the frame. (Actually there is another choice, which is to close in so tightly that the subject fills the frame, but we dealt with that already on page 16). A situation like the one shown below is a particularly clean example of subject-against-background, but the same decisions apply in many other cases. There's usually no need for precision when thinking about this, just a choice of three general positions: around the center, near an edge or corner, or this in-between position. Off-center may sound a little vague, which is good. You could call it a third of the way in, or a third of the way out, but if there is such a thing as a rule of thirds, it can only be approximate. Off-center has two strong things going for it. First, it's natural rather than forced or exact. Second, it makes for an easy, but definite relationship between the subject and the background. Whereas centered divides any background and diminishes it, while an extreme position near a corner makes the viewer wonder why that placing was used, off-center gently shows us both the thing and the setting together.

▼ Rice farmer, Chiang Mai Province, Thailand, 1979

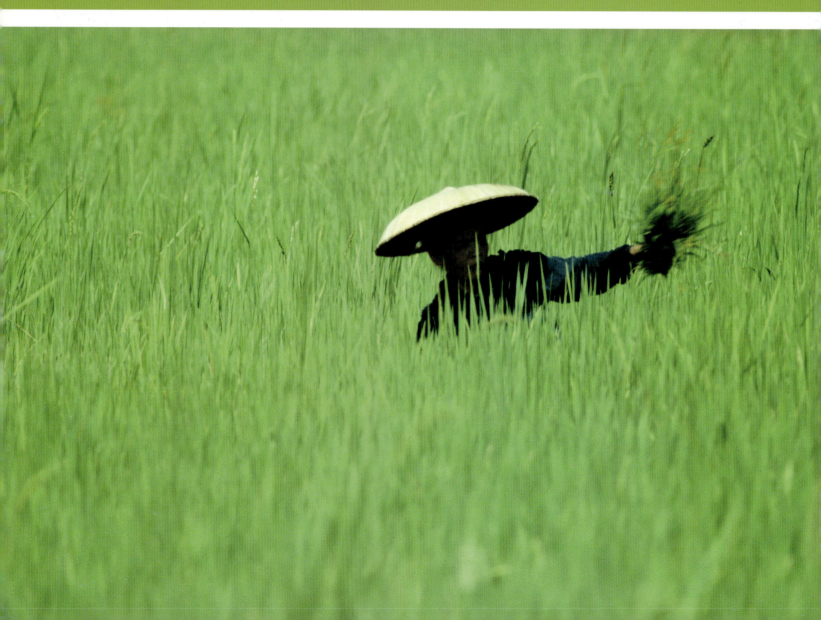

▼ In a field of green rice, placing the
subject off-center helps to relate it
to the setting.

▲ The three approximate zones
of a standard 3:2 frame.

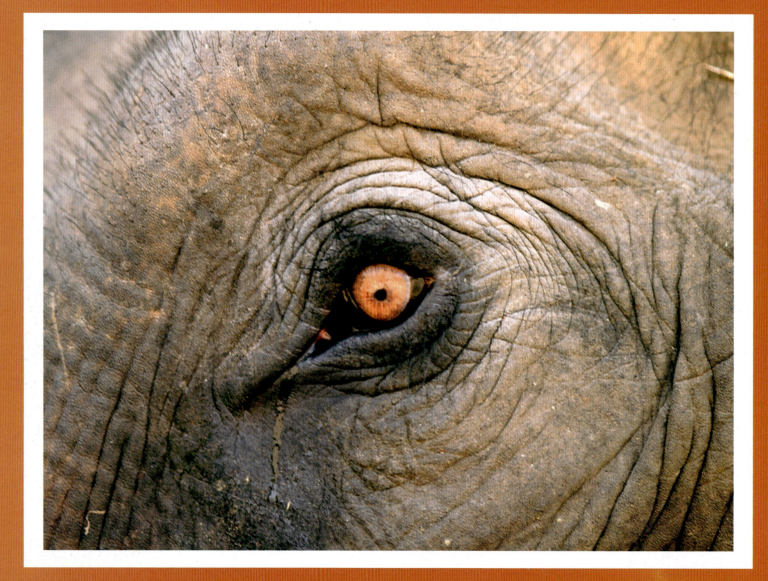

▲ Elephant's eye, Thailand, 1998

Off-center is certainly the most popular idea for placing a subject, and tends to come naturally to practiced photographers, but don't let the accompanying criticism of dead-centered, bull's-eye positioning make you believe it has no use. Far from it, there are any number of situations in which centering the main subject makes a firm and strong statement. Here is one: the unusually bright orange eye of a Thai elephant; and this makes a difference—a more normal elephant eye is not so insistent. Eyes attract attention more strongly than probably any other kind of subject, and this one is both colorful and circular. Because of the shape of an elephant's head, the eye sits within a fairly flat area of skin. More than that, most of the folds in the elephant's skin are arranged in curves around it, like sections of concentric circles. Everything points to the center. Remembering how a square format (page 22), with its equal sides and sense of strict enclosure, tends to concentrate attention towards the center, there is a good argument for cropping this image, shot on 3:2 format, to square.

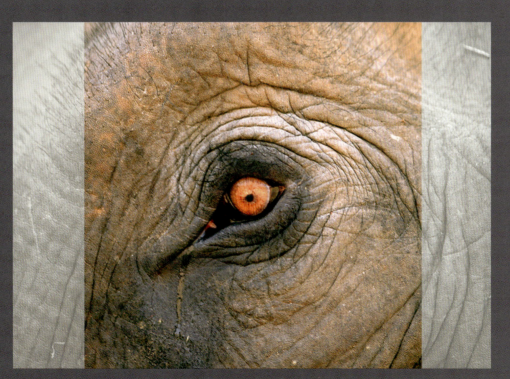

 ► The strong visual pull of the bright eyeball makes centering natural, reinforced by the concentric skin folds.

► Cropping to square would make even more capital out of the centering, with equidistant corners and edges.

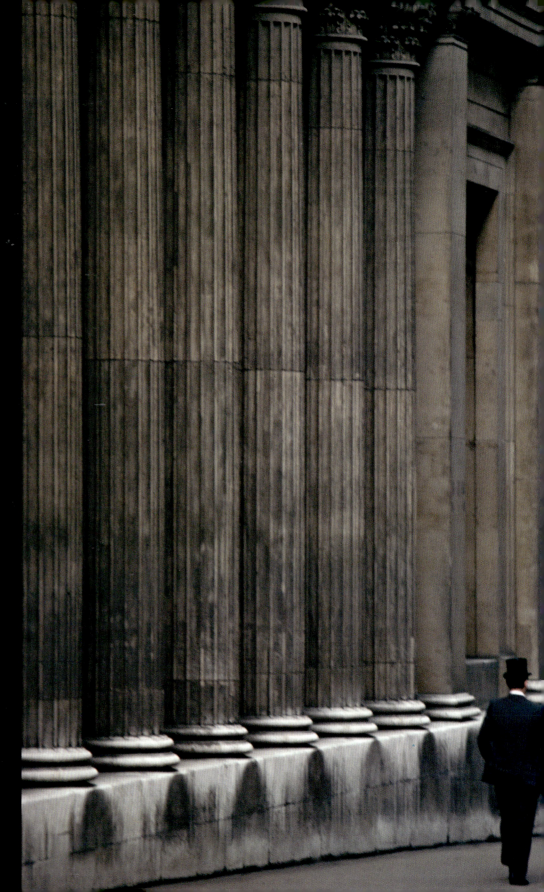

EXTREME

Of all the places to put a subject, right at the edge or in a corner is the most extreme and, frankly, the least likely. As the frame is meant to enclose, there needs to be a reason for doing something like this, otherwise it just looks perverse. There are many possible reasons, and they depend on the scene and what the photographer is trying to show; but as long as there's some logic, the viewer is likely to accept it, although not necessarily agree. One reason that crops up quite often is to make the background dominate the subject, and the most common situation involves a human figure and a specific setting. In this case, there was an entirely logical and graphic reason for placing the top-hatted stockbroker (yes, some used to wear top hats) in the lower corner. The shot was actually about the Bank of England, with its distinctive columns, but they needed the help of a passing figure. The illustration explains the idea further. Filling the frame with columns, without the gaps, required this acute angle, and the sidewalk drops away. That leaves just that small triangle of space at bottom right.

Stockbroker and the Bank of England, 1976

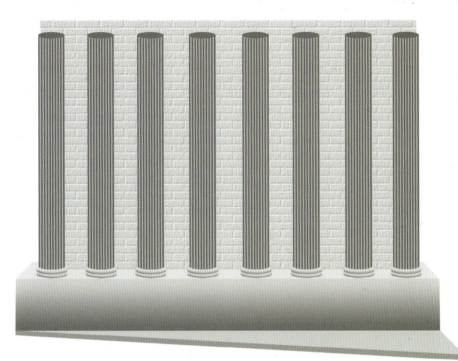

▲ Visible gaps between the columns make this shot less successful, or at least less simple.

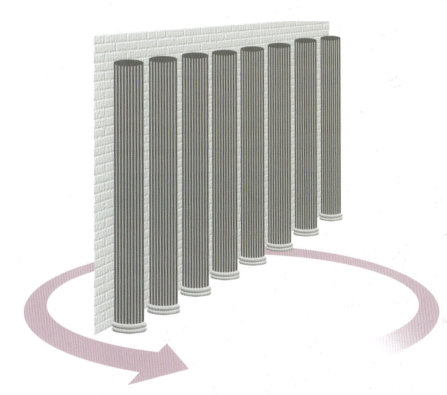

▲ The columns make a strong background, but more so from an angle that hides the wall behind.

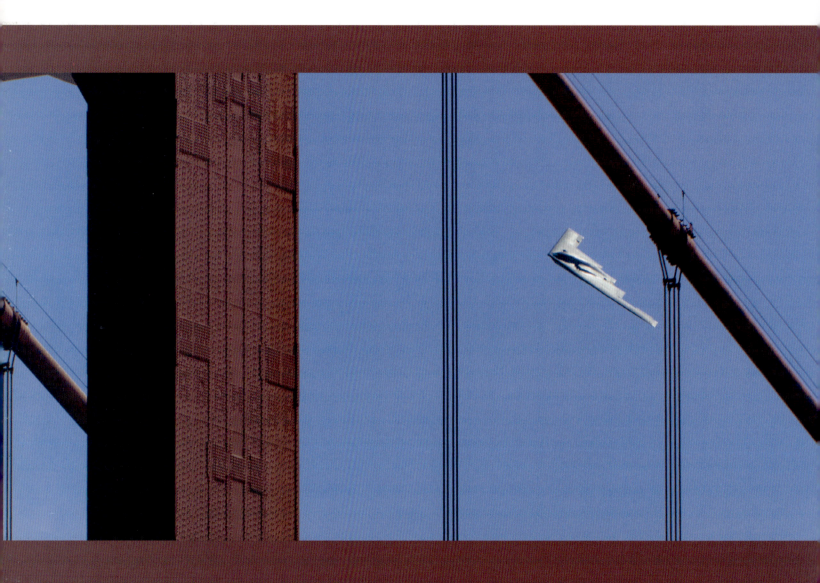

FRAMED

In this sense, framed means another frame within the scene. Windows, doors, and other man-made openings are frames onto another picture within the picture, and while there's no compulsion to use them like this, it can work quite comfortably. In fact, if something is passing behind a window of some kind, the near-universal reaction is to shoot at the moment when that subject is cleanly within it, not breaking any of the edges. You could argue that this very natural photographer's reaction makes it worth challenging, but in a case like this one you would have to be strong-minded not to place the aircraft neatly in one of the gaps of San Francisco's Golden Gate Bridge. Doing it any other way would look like bad camera work, and would probably be just that. As the sequence shows, there were only eight seconds and, at the start of shooting, no guarantee that the B-2 stealth bomber would fly neatly into the different frames. It did, and that was luck. Timing is everything.

▲ B-2 bomber and Golden Gate Bridge, 2011

▲ The aircraft's eight-second transit behind one of the bridge's pillars.

JUST

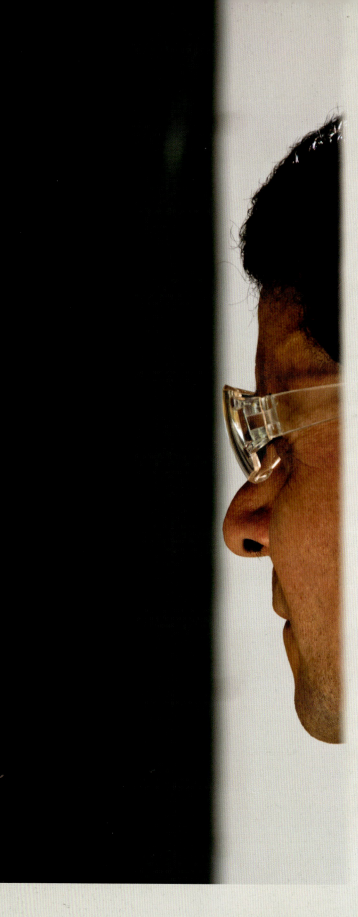

This is just a personal idea of mine, but one I like. Graphically, it means "almost touching." A foot about to touch the ground; a door about to close; a bird about to land—there's something of both the exact and the not-quite co-existing, which in a way is strange. It's an idea in composition that hovers between complete and incomplete, which some people might think needs resolving, but one which I think is more interesting. Through the camera, the "just" moment does not need to be real. It needs simply to be apparent. Here, the man's nose is not, of course, touching or about to touch anything, but the camera viewpoint introduces us to the graphic possibility. More to the point, the viewer's eye is drawn to this uncertain area simply because it's unresolved, and gauging the exact size of the gap is something to think about. For this reason, "just" pictures can hold extra interest. You look at them and want to complete them.

➤ Shopkeeper, Bogotá, Colombia, 2007

▲ The situation—a profile sandwiched between two walls.

▲ Of the range of positions between sharp subject and less-sharp edge, the almost-touching option seemed the most interesting.

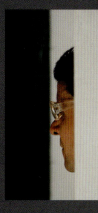
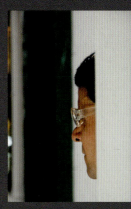

► The preceding shots, before realizing that a precise position is important.

FIGURE IN A LANDSCAPE

These are the biggest falls on the Mekong River, in Laos, and this is an attempt to give scale. Seen alone as a landscape image, they don't impress as much as the real thing because they lack comparison—the trees could be almost any size. What shows their size is the tiny figure of a fisherman, doing his dangerous daily work with a net, in the lower right. He was worth a close shot on his own, but the needs of the bigger view won, and I framed a panorama like this—classic "figure in a landscape," a type of image that dates back to at least the sixteenth century. Even so, there was the question of whether horizontal or vertical, and how small the figure could be in the image and still be seen. Too small and the point would be wasted. In the end, I settled for two versions. The vertical is probably the more impressive because the rocks and falls stack up above the man, but this wide horizontal also works under one condition: It has to be printed big. Take note of the moment of action as the fisherman throws his net. It makes a difference, as you can see from the set of closer views; and the shot I chose has, to my mind, more energy than the others.

▼ Khone Phapheng Falls, Mekong River, Laos, 2011

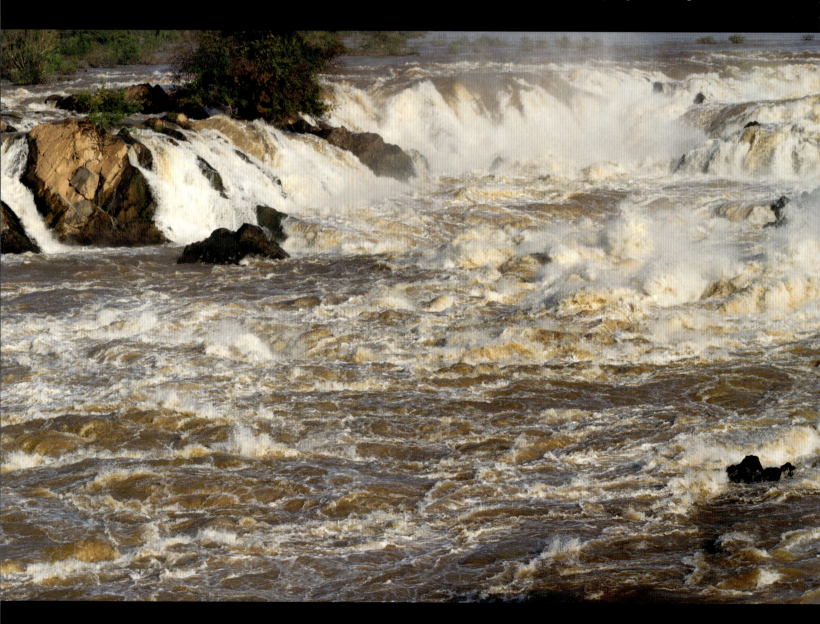

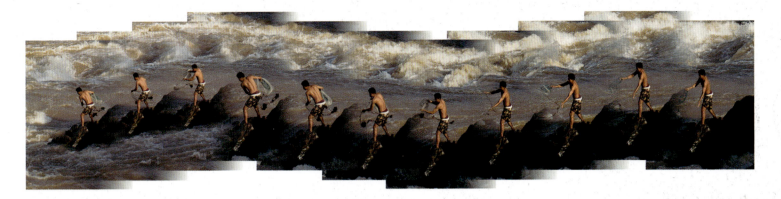

▲ Choosing the expressive moment during the fisherman's throw of the net.

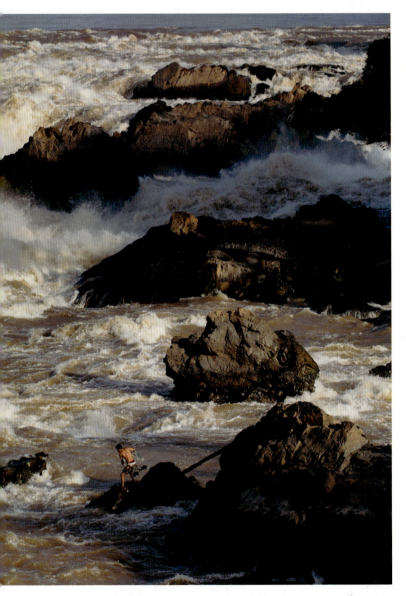

▲ Scaling the panorama to keep the fisherman as small as possible, but still noticeable.

▼ Whether or not the subject registers depends on print size.

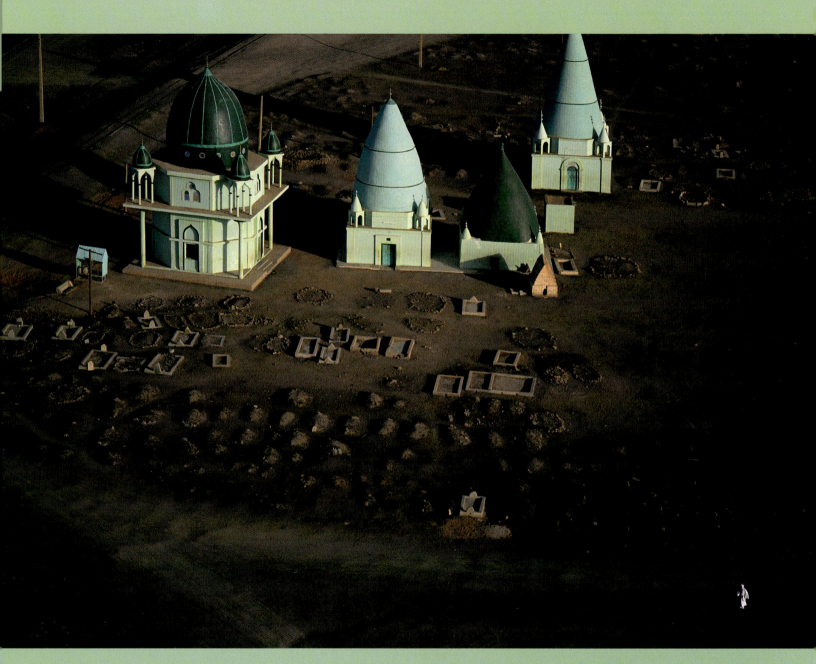

▲ Sufi Qbas, El Kabbashi, Sudan, 2003

THE PHOTOGRAPHER'S EYE: A GRAPHIC GUIDE

REVEAL

The reveal is a technique from the movies, and frankly difficult to achieve in a single still photograph, if not impossible. But let's try anyway. In a reveal, the camera starts by showing the audience one thing, but then moves or zooms to reveal something else, often unexpected, that's in the scene. Simple enough, but it can be very effective due to the element of surprise. The opening can lull the audience into thinking it's in a certain situation, but then, from one side or corner, the real object of attention comes into view. The only way to come close to this in a still image is to arrange the framing, composition or lighting so that all the attention immediately goes to one place, but the eye lingers long enough on the frame to start to wander, and then discovers something else. It's an uncertain balancing act, because if you hide the thing-to-be-revealed too well, such as by making it too small or poorly lit, chances are the viewer will get bored and move on before noticing it. This shot was from a helicopter over a group of Sudanese mausoleums know as *qba*, and needed fast thinking. The small white-clad figure makes the shot, but only because it takes the eye a moment to slip down to the corner to notice it.

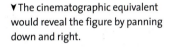

➤ The combination of different sizes and positions in the frame ensures that attention goes first to the mausoleums, then to the tiny figure. Both contrast strongly with the ground.

▼ The cinematographic equivalent would reveal the figure by panning down and right.

TWO SHOT

One of the classic shots, particularly in cinema and television, where interviews and conversations feature strongly, is what is known as the "two shot:" two people, usually framed tight-to-medium, so that their faces dominate. Widescreen suits this arrangement very well, because it allows the pair to be side by side with breathing space. One of the points of a two shot is that there's a relationship between the subjects, and it's often good to manage the composition so that the viewer's eye moves back and forth between them—in other words, the shot is active rather than static. This is Chinese opera, photographed onstage, and deliberately with selective focus at a wide aperture, f/1.4 with an 85mm portrait lens. Both the focus and the lighting are on the foreground figure, so that is where the eye first goes. But the contrasting backgrounds (right dark, left light and colorful) help make sure the eye then goes to the blurred, but still recognizable, actress. Then, the more dominant actor brings the eye back. The attention plays ping-pong between the two subjects.

▼ Chinese opera, Singapore, 2009

▲ ➤ At ƒ/1.4, the lens is focused narrowly on just one plane.

▼ Attention starts on the brighter, focused foreground figure, then moves back, only to return again.

PART 3
DIVIDING

There is not always something to divide in an image. Think horizon line and you have the cleanest and clearest example of a necessary division, but many images are just too complex, or too simple, to lend themselves to any useful kind of division. At its crudest, you need lines to divide a frame, and the straighter they are, the cleaner the partition. Horizons are known and expected, and in a way are the equivalent of the single subject against a plain background that opened the last chapter (page 30). That is, you have to put them somewhere: high, middle, or low. But there are other lines that may sneak up on you and insist on splitting up the frame, particularly if they are edges of things or areas, and even more so if what goes on either side is very different. It may be dark against light, one color against another, different textures, or just about anything that creates a contrast.

THE PHOTOGRAPHER'S EYE: A GRAPHIC GUIDE

CLASSICAL

I may be stretching the term "classical," or even misusing it by suggesting that it's to do with classical painting, but I mean the kind of approach to composition that is well accepted, comfortable on the eye, and is what any well trained photographer would do to produce a generally satisfying image. It may or may not involve dividing the frame according to the Golden Section, more or less, and that doesn't really matter; above all, it's about innately satisfying proportions that balance larger against smaller, and darker against lighter. Our eyes are drawn to the light, and brighter usually gets more attention, so classical proportions take this into account. Just for interest, see what happens if we manipulate this image to divide darker and lighter along the Golden Section. It doesn't work well, and the bright sky over-dominates, although if we made the tones more equal, it would be more comfortable. But this is all about satisfying the eye rather than challenging it.

➤ By depth, the three principal areas are the foreground slope, the gray middle distance of mountains and clouds, and the pre-dawn sky.

▲ The zones rendered schematically, to show the proportions more clearly.

◄ Sierra Nevada de Santa Marta, 1974

▲ If the scene had been composed according to the Golden Section, as here, it would be unbalanced by the tonal differences (left). It would work only if the tones were equalized (right).

SYMMETRICAL

For some reason, symmetry often gets criticized, generally on the grounds that it shows lack of imagination. Like other things in composition, it has a time and a place. One occasion for using it is when you seriously need to bring order to a scene or subject that has none whatsoever. Here are 23 rare orange pearls, the subject of a magazine story, and they needed to be arranged and placed somehow. This meant doing more than simply emptying them on a table like a bag of marbles. First, they needed a background, and I went for contrast and texture with river-worn pebbles, meticulously blackened with shoe polish by an assistant. These had the advantage of offering resting places in the gaps, and we tried a number of arrangements, all of them attempting some sort of pattern. This was one.

➤ Orange pearls of the last Emperor of Vietnam, 1997

▲ The 23 pearls before assembly. The large number and different sizes posed a problem in organization.

▲ The blackened river pebbles.

▲ The basic unit of the composition was a pearl nestled in the gaps between pebbles.

ECCENTRIC

These are the forested banks of the Amazon River in Brazil, and even though this strip of trees is the only distinct and sharp subject in the picture, they're about to slip out of the frame. Why? Why not divide the shot in a more ordinary way, with the banks a bit higher, where the audience might expect them? There's more than one reason. Practically, there isn't anything of interest in the water itself, but above there's a tropical storm brewing, though pale and subtle. I want the viewer to look at this, but for it to make sense, the clouds have to be keyed to the ground. The eye will naturally go to the one sharp strong element—the tree line—but with it so low in the frame, the eye then wanders elsewhere, and there's only one place to go: up. The initial subject is a detailed dark line of trees that we pay extra attention to, but the ultimate subject is the swirl of storm clouds. Having the treeline aligned exactly to the edge adds interest (this was shot on film; no easy digital straightening up later).

▲ In contrast to the smooth, soft clouds, the only subject of precision is the treeline, which gives it heightened prominence to the viewer.

◄ The already simple scene simplified even further to show the relationship between clouds and treeline.

◄ Afternoon storm over the Amazon, Brazil, 1971

DISRUPTIVE

Remembering that one of the prime jobs of composition is to keep the interest going, there are times when it may be a better idea to go against the expected ways of focusing attention clearly on one subject. The bright portraits (politicians' publicity campaign) on the side of this cart in Chennai, India, were naturally eye-catching, but needed some animation to become a photograph. That came in the form of the poultry being loaded in baskets, and it seemed more fun to frame and angle the shot to divide it in a way that doesn't let the eye rest anywhere for long. In particular, there was a little game to be played with faces, given the right moment for the live action. The result, visually, is deliberate disruption, but that makes the image more energetic.

▲ The basic graphic division is rectilinear, but at an angle.

▲ The four faces of different sizes, each in a squared-off segment, help to key the composition.

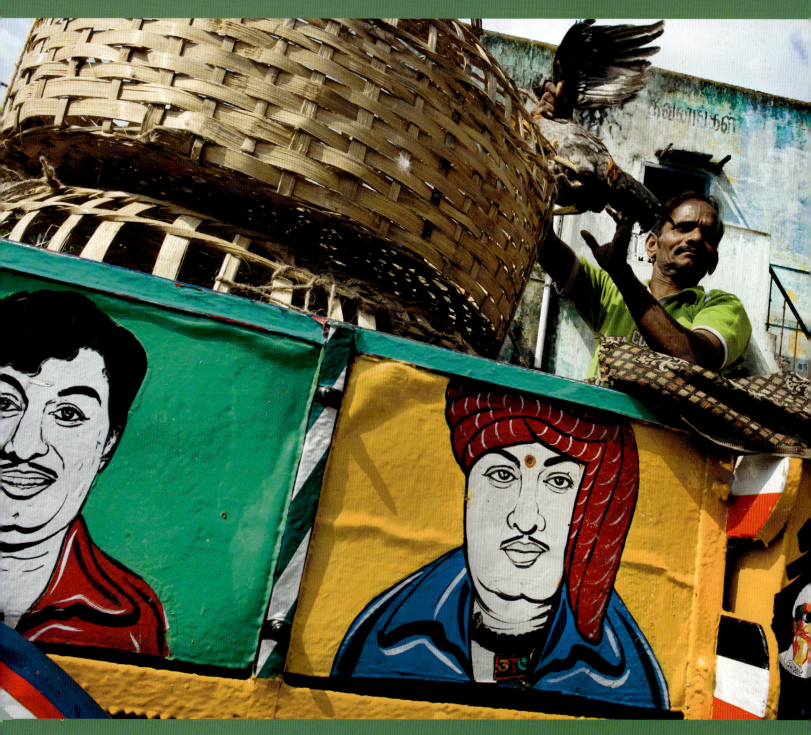

▲ Politicians' faces on a poultry cart, Chennai, 2009

ANGULAR

The last image used an angled framing to energize the scene. We'll see diagonals in action in the next chapter, but here I'm using them to make a clean and definite division. One other element I'm using for division is the waterline of a still swimming pool, and this gives double value to the striking hard shadows that take up the left half of the frame. This is a villa in Portugal built with a strong modernist flavor and mainly white surfaces—there were endless opportunities for abstracting. The diagonal shadows converge with their reflections like chevrons, or an arrow that points to the yellow chairs. The waterline is deliberately not centered because the reflections are slightly softer and weaker. And I waited for the leading diagonal to reach the corner of the small square window— just. Note also the value of a head-on, flat viewpoint (see Four-square on pages 82–83), which sets the diagonals off against the strict horizontals and verticals of everything else.

▼Villa, Algarve, Portugal, 2009

▲The setting from a distance.

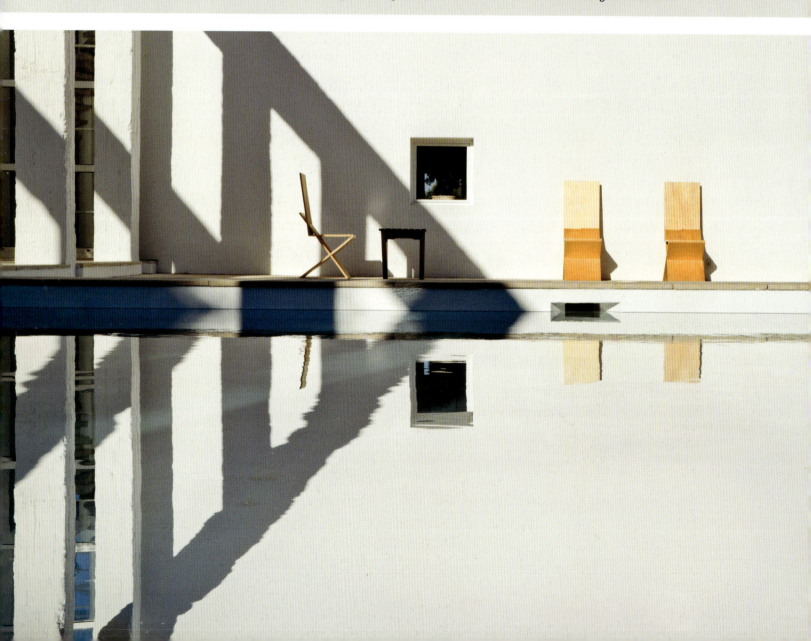

◄ The shadows, doubled by the reflection, create a diagonal movement, helped by the target of the yellow chairs.

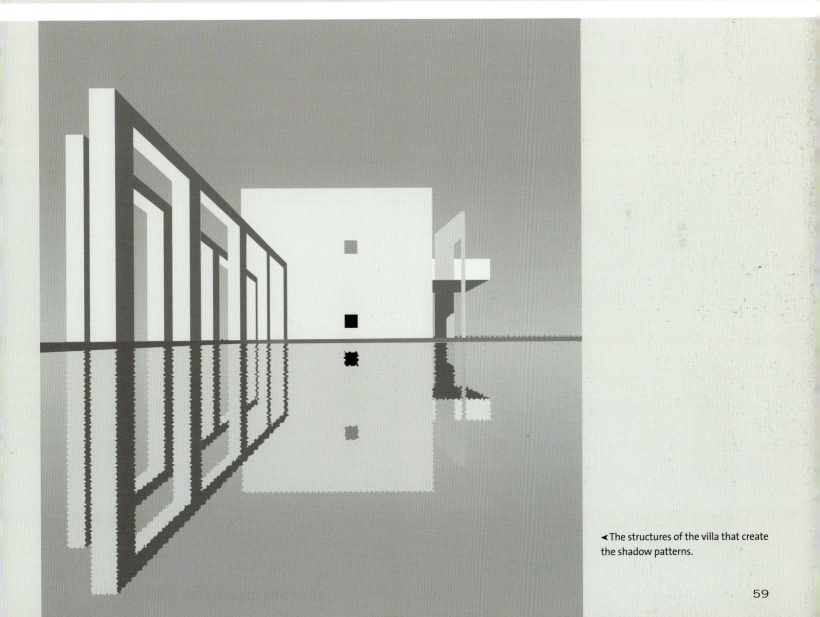

◄ The structures of the villa that create the shadow patterns.

RECTILINEAR

Not a diagonal in sight here, and even the oval boxes are squared up and on parade. This is a Shaker pantry cupboard in Massachusetts, and the Shaker communities of the nineteenth century were highly ordered places, with simplicity and plainness a practiced virtue. Many man-made things, especially buildings, cupboards, boxes, and so on, are rectilinear—constructed of verticals and horizontals; so you could rightly say that there's no great imagination involved in shooting them that way. It involves setting up the camera level, using a normal-to-long lens, and facing them exactly. But in this case, for a book on the Shakers, it was more a matter of treating the subject in its own spirit. The characteristic wooden wall rails and pegs, from which anything not being used at the time were hung with a sense of discipline, sets the tone.

▼ Shaker interior "design" policy emphasized order and discipline, notably in the wall rails for hanging anything not in use.

▲ Everything in the image resolves into ordered, rectangular shapes.

➤ Shaker pantry, Fruitlands, Massachusetts, 1985

PART 4
GRAPHICS

The graphics in an image are its basic and clearly defined visual elements, mainly lines and shapes. Or, in the case of photographs, what we think we see as lines and shapes, because strictly speaking, graphics are the province of artwork and illustration. Graphics in a photograph are usually the result of edges, contrast, and whatever associations our eyes and minds make up. By no means all photographs have them, and that is part of their appeal when they come into play, because they depend on the photographer to find and exploit. A graphic photograph is one in which lines and shapes play a strong part, often stronger than the subject. Using them, and using them well, is a visual skill. As we'll see, they can be suggestive and give a certain character, because a pronounced curve, for example, plays a different game with the eye than does a straight line. And a vertical line gives a sensation different from a horizontal one. And so on.

HORIZONTAL LINES

Here was a way of dealing with an over-photographed subject, Upper Yosemite Falls in California's Yosemite National Park. The weather was good—an October storm had just cleared the evening before, leaving the early morning crisp and clear, so a guaranteed early morning sunlight would fall across the south-facing falls. This was the perfect moment to shoot: The water and spray had just begun to catch the light; the sun was at the right height; and the view was inspiring for both tourists and photographers. Walking around, I knew that a foreground of some sort would help, and it would probably involve trees, and at this time of the morning probably also a silhouette, as the sun had not yet reached this part of the valley. I noticed these mainly horizontal branches, intersecting between two big conifers, and thought of a ladder. To keep it graphically simple, I did not want the sky, which meant cropping tightly with a telephoto lens. And for the effect, I needed everything sharp, which meant plenty of depth of field. I stopped down to ƒ/32, which meant 1/5 second and accepting some softness in the falling water.

➤ Upper Yosemite Falls, 2011

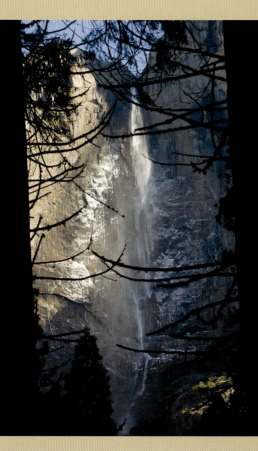

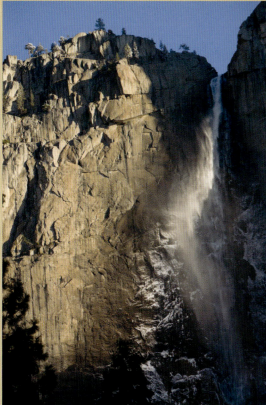

The silhouetted horizontal branches appear as a kind of ladder in the foreground, overlaid on the scene beyond.

◄ A clear view of the falls.

VERTICAL LINES

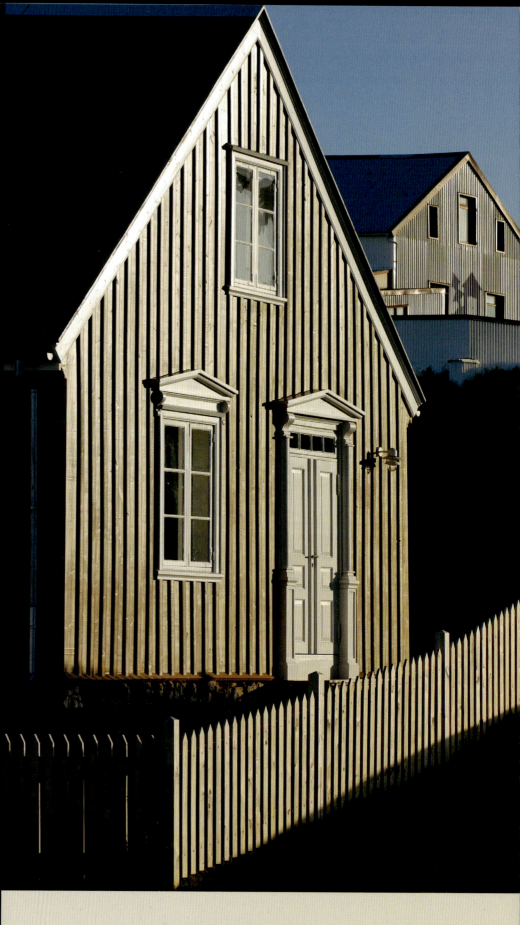

This did not begin as an image about vertical lines. I was more interested in the clean geometric Icelandic architecture; but in the course of walking around to find the best viewpoint, I watched the play of light change. From here, the vertical planking and picket fence were catching the low sun intensely, and I was happy to let the crisp contrast take over the image. It may look like late afternoon, but this was June in Iceland, and it's almost ten oclock in the evening. At this point, far from wanting to balance tones, I actively wanted strong contrast so that the vertical lines would dominate. I took time to find this exact viewpoint: reflection in the façade at its strongest, picket fence prominent, distant house neatly positioned at top right. I processed for contrast, and then cropped to eliminate anything that would distract from the verticals—the window at left and the lit grass below—and shaved the frame at top and bottom. If you don't mind altering the geometry in post-production, a further touch might be to straighten the roof ridge from diagonal to horizontal and crop even more tightly.

➤ Wooden houses, northern Iceland, 2008

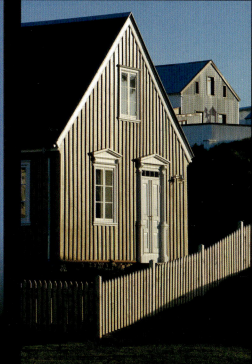

▲ The original frame, uncropped, with slight distractions left and below.

◄ Using the Photoshop Distort tool to level the roof ridge, allowing a tighter crop and more attention on the verticals.

DIAGONALS

These are always useful when you want to bring action, a sense of movement, and strong angles into an image. Diagonals carry the eye along them, up or down, and generally enliven things. They come into play if you angle the camera up, down, tilt it, or shift the viewpoint—especially with a wide-angle lens. The diagonals in this wide shot of St Peter's Basilica in Rome are entirely a creation of the camera angle and lens, and were designed to make a version of this famous space that was more dynamic and impressive than architectural. The shot was timed for late afternoon, when the shafts of sunlight stream down in this position; the light anchored the framing. The viewpoint was chosen to include the two foreground *putti* on the left, for depth. But what would have happened if the camera had been leveled? The shafts of light would have been longer, certainly, but overall it would have been less dynamic, more rigidly architectural. Angling the camera like this makes all the verticals in the scene diagonally counter to the light shafts, and this opposition brings a different kind of energy to the shot.

➤ The setup, here with a 65mm Panavision camera.

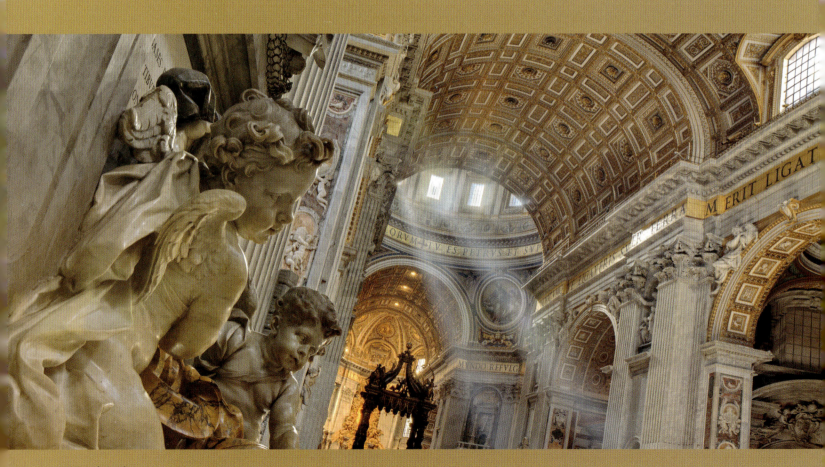

▲ St Peter's Basilica, Vatican, Rome, 2009

◄ Un-tilted, like this, gives a more formal, and less energetic image that fits more into the category of formal architecture.

➤ Rotating around the Z-axis adds a complete set of diagonals to the already-diagonal light shafts.

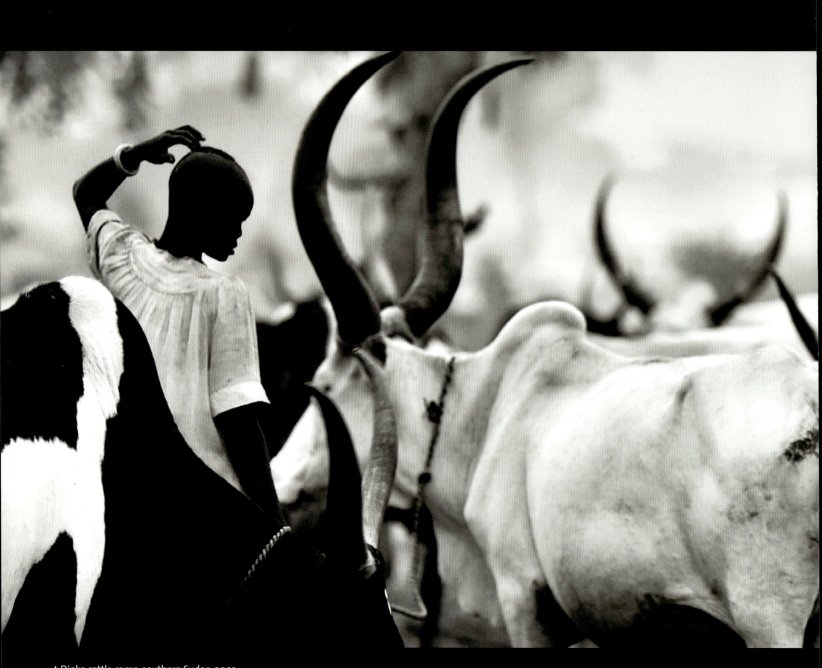

▲ Dinka cattle camp, southern Sudan, 2003

CURVES

Curves come in all varieties, as you would expect, as they have a free-form flow that is the complete opposite of strictly ordered straight lines. Occasionally, they flow in a way that we find elegant and sinuous, and one of the strange things about them is that people actually like, instinctively, a beautiful curve. They even make some people smile. Without getting into the psychology of curves, they are undoubtedly good to play with in photography, but it means doing something with them in the frame and not just settling for a straightforward shot. This was a Dinka cattle camp in Sudan, and one thing to know about the Dinka is their passion for cattle. A fine bull is a Dinka man's most treasured possession and companion, and a fine bull has wonderfully curved horns. The Dinka are aesthetes of curves, and a camp like this is rich in imagery. This was one of my favorite shots from the take because of two coincidental curves beyond the obvious horns. One is the moment of the man raising his arm to his head, and the other is the intersection of this with the outline of a bull in the foreground. The illustration better explains why I think the image works.

▲ The active part of the frame, where the curves cross over each other.

▲ The curved outline of the foreground bull defines the corner so strongly that it almost separates. Around this edge, curves flow in several directions, but they are all related.

TRIANGLES

Triangles can be "real" in the sense that the three sides are obvious and apex points, but they can also be implied, or suggested. Implied triangles are the most frequent shapes in imagery simply because they happen with any three prominent points. As the arrangement of the three Mao badges shows on the opposite page, even if just thrown down, they connect in the eye. Additionally, if there is a difference in size (as there is with these Mao badges), the eye puts them into perspective—literally. The main picture, however, has a real triangle, made very briefly by the cloth as the man, who has just been bathing in a south Indian temple, prepares to wrap it around himself. As the scene unfolded, I was not quite expecting this, but it was worth shooting, not least because the lines of the triangle are gently curved, and they make a double triangle with the man's outstretched arms. As with any shape, such as the circles which follow overleaf, triangles are worth the shot if for some reason they are a little unexpected or unpredictable. But this is true of photography in general; we like to see what we can't predict, not what is already obvious.

▲ A few minutes earlier, a similar action from another bather (there were several) suggested the picture possibilities.

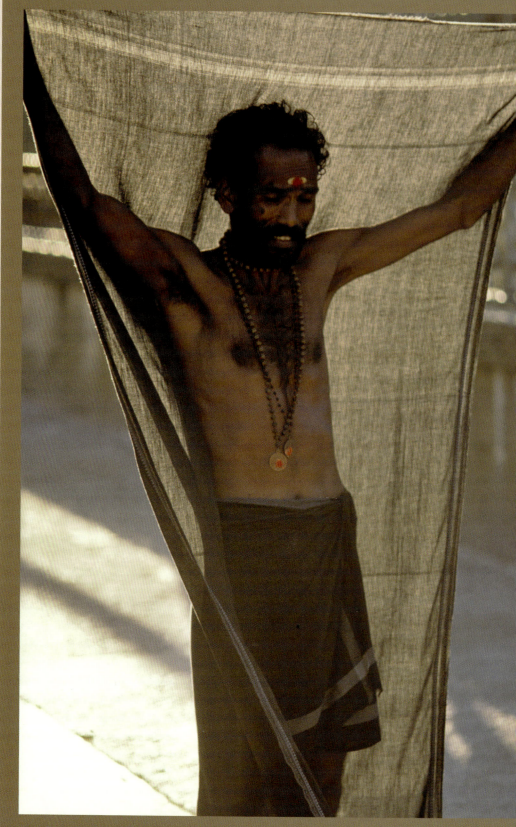

▲ Pilgrim after bathing, Arunachaleswara, 1998

▲ The man's raised arms reinforce the gently curved edges of the triangle of the cloth.

▲ Any three distinct objects imply a triangle.

▲ If the objects look similar but vary in size, it suggests depth and perspective.

CIRCLES

Implied circles are much more interesting than those that are complete and ready-made (like a clock face), though they don't happen as often as, say, implied triangles (see pages 72–73). Here was one. The location: a Buddhist convent in Sagaing, a religious town near Mandalay in Burma. The job: a book for Thames & Hudson on sacred sites in Asia called *Sacred Places*. The occasion: preparations for one of the festivals in the Buddhist calendar, called Kathin, at which new robes are presented to monks—along with food. On arrival, we were shown where nuns were preparing the ceremonial meal. It's standard procedure to explore alternative camera positions. Up on the balcony surrounding the courtyard was a natural first for a general overview. The groups of nuns gathered around mixing bowls immediately caught my eye, and one neat group in particular. So, I got closer, overhead, and changed to a longer lens. From that moment, this was going to be the shot, and it came easily. Special here was the set of concentric circles, repeating each other in different ways, slightly overlapping, and stacked one over the other, as shown in the diagrams on the opposite page. The focus was the mixing bowl, and the arms formed spokes to the wheel.

➤ Nuns preparing food, Sagaing, Burma, 1996

74

▲◄ The elements of heads and robes make a stack of overlapping circles, centered on the radiating arms.

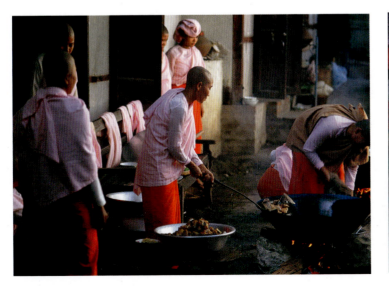

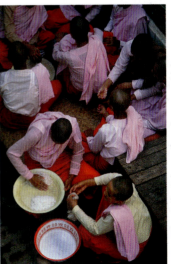

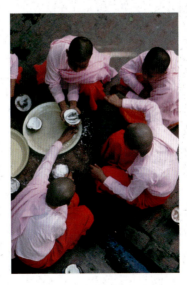

▲ The sequence of shots leading up to finding the overview.

RHYTHM

Just as in music, there's something satisfying about having a kind of beat operating in a picture. Of course, music requires a beat, while it's not all that common in imagery; but when there is repetition, it's worth investigating how to make use of it. Repetition has its boring side, without a doubt—things just appearing one after another too predictably. But when there's a distinct set of subjects that in some way align and flow, it can give the image an unexpected structure. You might think that a group of similar objects is hardly a recipe for the unexpected, given that so many things are made in multiples. However, your unique treatment and viewpoint could make a huge difference. These are a famous group of memorial arches in Anhui Province, China from the Ming dynasty. Looking for a higher, slightly distant viewpoint, as in the black-and-white shot, was part of the usual procedure, but the result is uninspired. The next morning, making use of the slight fog to enhance the scale of distance, a closer viewpoint with a wide-angle lens (and a shift lens, also—see pages 92–93), produced a much better sense of the rhythm of these powerful structures.

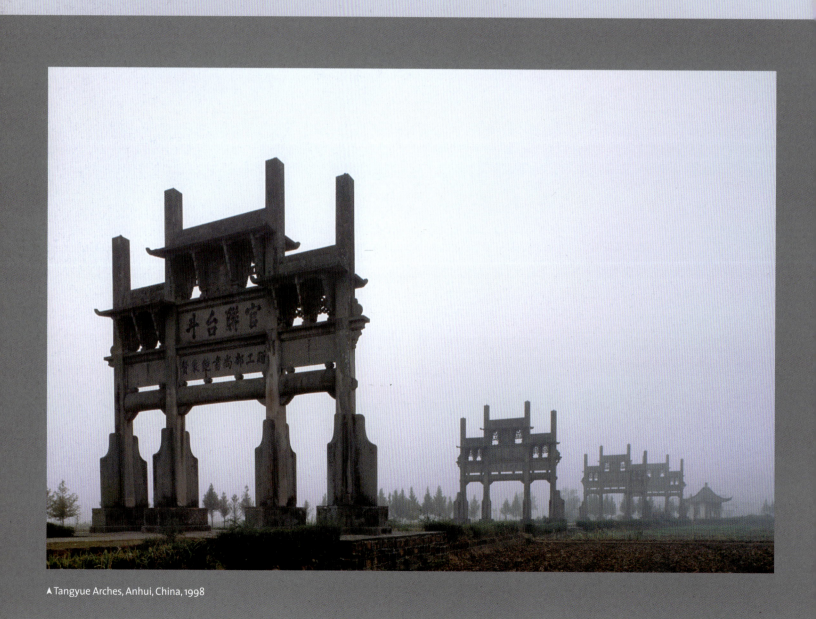

▲ Tangyue Arches, Anhui, China, 1998

◄ The elevated view from a distance.

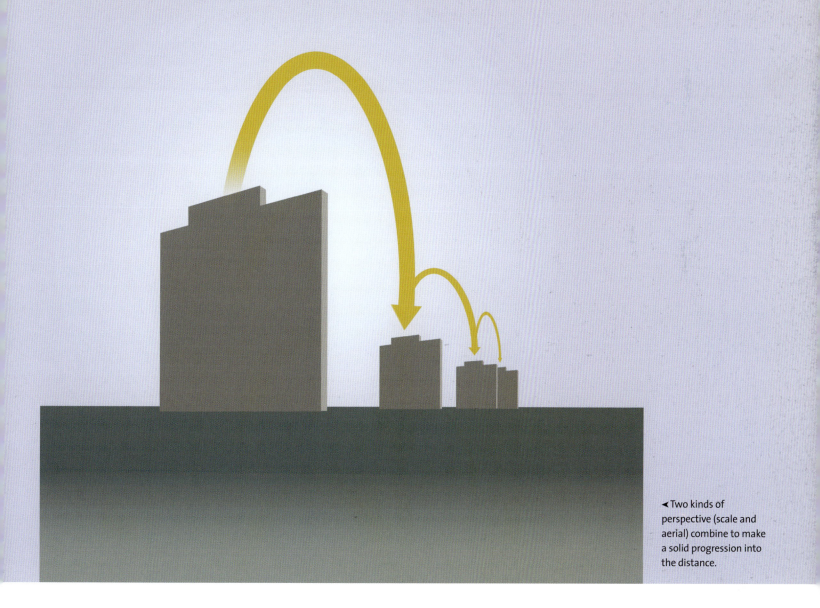

◄ Two kinds of perspective (scale and aerial) combine to make a solid progression into the distance.

PATTERN & FIELD

What makes a pattern is the repetition of something graphic, like a shape. A field image is similar—a view of many similar things, from a field of poppies to a field of stars. The repetition and the numbers involved make a pattern or a field a possible subject for a photo, but there are conditions. There has to be some surprise or some curious element for it to be worth shooting or looking at. A pattern of bricks making up a brick wall is hardly interesting, and even a field of flowers has to be especially pretty or dense, or have something be eye-catching. And while I say eye-catching, pattern and field images can succeed by being visually striking, but they can also sometimes succeed by content alone. Imagine a million people in one photograph, or a hundred whales, and you get the idea. Here, the pattern is attractive, but also ambiguous. These are a new design of LED light bulb, but they looked to me like nineteenth-century *millefiori* glass paperweights, so I shot them as a mass. I didn't touch a thing to arrange them, but I did what was essential for this kind of photograph— framed them so that they run off at all the edges. This alone suggests that they go on and on.

PART 5
VIEWPOINT

The search for a different viewpoint is built into most photographers' behavior patterns. It becomes second nature, and for a good reason. Most photographs, at least of the unplanned variety, begin life as something spotted from a distance. There's the hint of a potential. Once the subject has been decided, however, there's the question of from where it will look best, or most interesting—the camera angle, in other words. This might certainly be from the starting position—maybe that viewpoint was part of the reason why it caught your eye—but most of us, if we have the time, also want to explore other possibilities. After all, we're there, the subject is there, the occasion is not likely to repeat itself, so it probably is worth the extra effort to see what viewpoints are available, and then choose the most effective one.

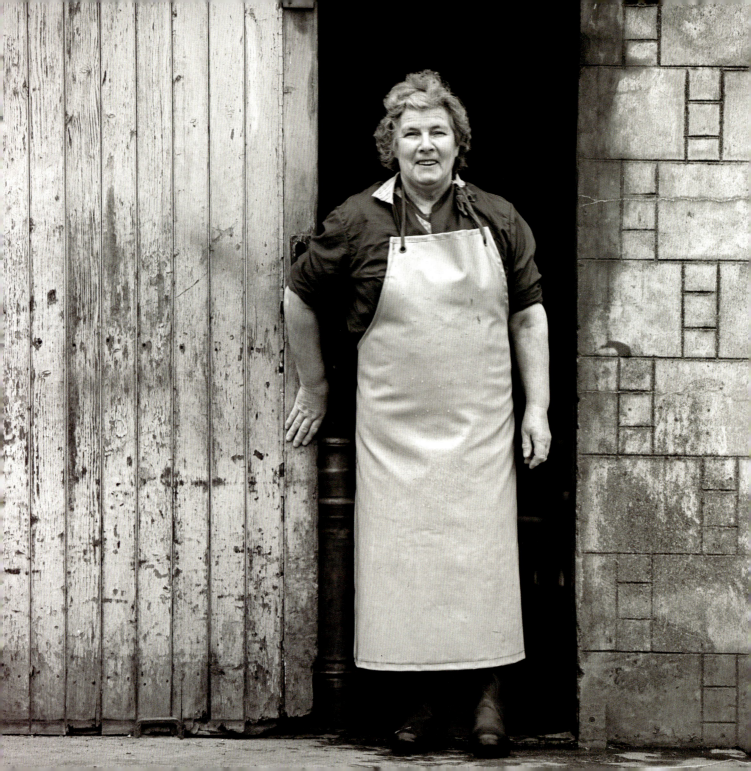

FOUR-SQUARE

▲ Even a slight angle to this subject becomes more casual, less deliberate.

Sometimes criticized for being unimaginative, but in fact very useful and simple, a four-square viewpoint faces its subject head-on, frontally, with all the major lines squared up and rectangular. Magazine picture editors and art directors like it, especially for covers, because the horizontal and vertical alignments take headlines, mastheads and other typography very well. For it to work, you need to be very careful about centering the camera and leveling it; a grid overlay on the viewfinder or live-view LCD is always useful. This is easier with a standard or longer focal length than a wide angle. Because it is such a practical, open-eyed approach, some people have delusions about it being somehow more objective and "straight." It certainly looks as if you're approaching the subject head-on and without fancy dramatic angles, which is why it has become the treatment of choice for documenting things, people, and places. Many photographers have used it, from August Sander and Paul Strand to Bernd and Hilla Becher.

◄ Farmer, Lancashire, England, 1973

HIGH

Overviews appeal to our sense of wanting to see things laid out before us. The bird's-eye view is a privileged one, somehow commanding and putting us in charge. An illusion, of course, but a pleasant one. Tall buildings and clifftops are all co-opted these days for this experience, and the scenic overlook is a sign-posted stop on a national park route. Aircraft and even balloons join in as desirable camera platforms. One thing often missing from these vantage points is the evidence of the viewpoint itself. Admittedly, you may not actually want it interfering with the view, but there are times when it adds to the scene. The problem here, on a small and rarely visited island in Indonesia, was how to make the most effective image of an iron nineteenth-century lighthouse, showing its delightful setting. In other words, combining two elements: lighthouse plus tropical context. I tried many, but far and away the most successful was the almost aerial view from the top, making sure I waited until later in the day when its shadow was longer. The lighthouse is the subject without actually appearing in the picture.

▼ Tanjung Binga lighthouse, Billiton, Indonesia, 2012

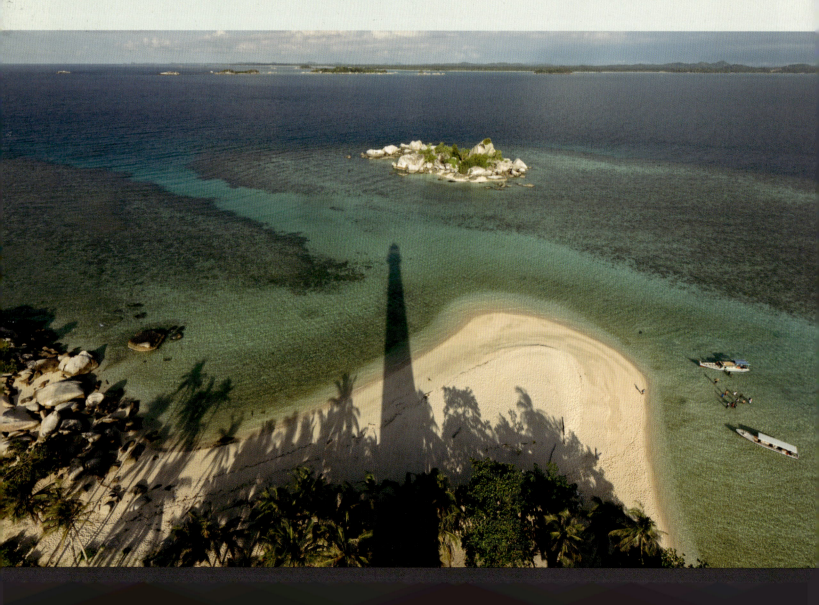

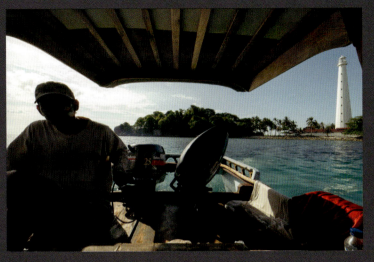

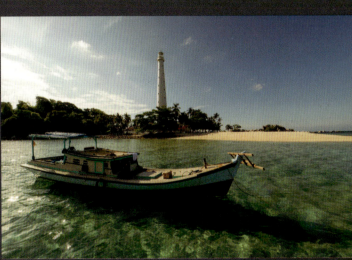

◄▲ A typical workaround from sea level, fitting the lighthouse with a variety of foregrounds.

OVERHEAD

Overhead is an especially tempting viewpoint, because it is so easy to imagine and yet usually difficult to reach. Standing in front of your subject, you look up and think "bird's-eye view," because from above is likely to be a privileged view, not available to most people, and that alone suggests a different image. The search for visual surprise becomes all the more pressing when the subject is well known and and already thoroughly photographed, as here, with Stonehenge, which is one of the UK's top tourist attractions and brings in a million visitors each year. Overhead gives a plan view, which often holds out the possibilities of a shape of some kind, and the broken circle of gray stone sits nicely on a field of green. The only way was a helicopter, and shooting from this, as from any aircraft, means an open door or window, and the pilot circling tightly so that you have a constant view downward. Flying over Stonehenge, however, is prohibited (in case something falls, like a helicopter), but the pilot was understanding and no one seemed to be waving their fist at us, so we drifted over.

◄ Stonehenge excavation, 2008

◄► The aerial shooting involved circling tightly in the helicopter so as not to waste any flying time. This rotated the camera view above the stone circle.

LOW

One good reason for shooting from a low point (kneeling rather than standing) is to take in less of the foreground, such as a sidewalk or street. Another is to inject some angles—a little drama and presence into the picture. This was the idea for a shot of a horse caravan that eventually became the cover of the book I was shooting. I had already chosen the site, which was an old lane in an old Chinese town, one that had a nicely curved and whitewashed wall—a near perfect frame for the horses and men as they walked by. I also had time to prepare, and a ground-level viewpoint would not only show more of the horses against the white wall, but also make it a simply more interesting image if I shot with a wide-angle lens, lying flat on my back.

▼ Horse caravan, Heshun, southwest Yunnan, 2009

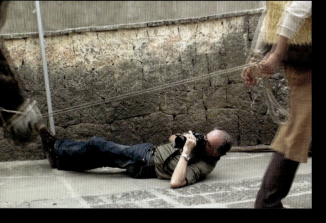

▲ The viewpoint, with a 24mm lens.

▲ The chosen angle has a strong sense of radiating movement outward.

▲ Adding the horse caravan enhances the outward dynamic.

▲ From the shooting sequence, this image had the clearest separation of man and horses.

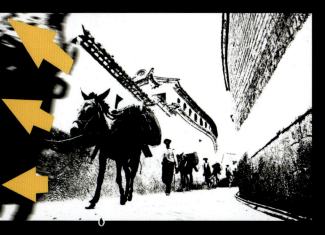

▲ The edge of the man reads clearly, but has a slight blur that adds to the sense of movement.

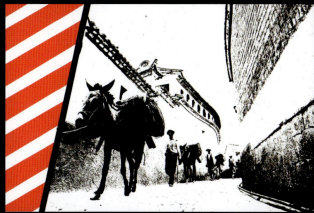

▲ The edge of the man also serves to close off the frame graphically at left.

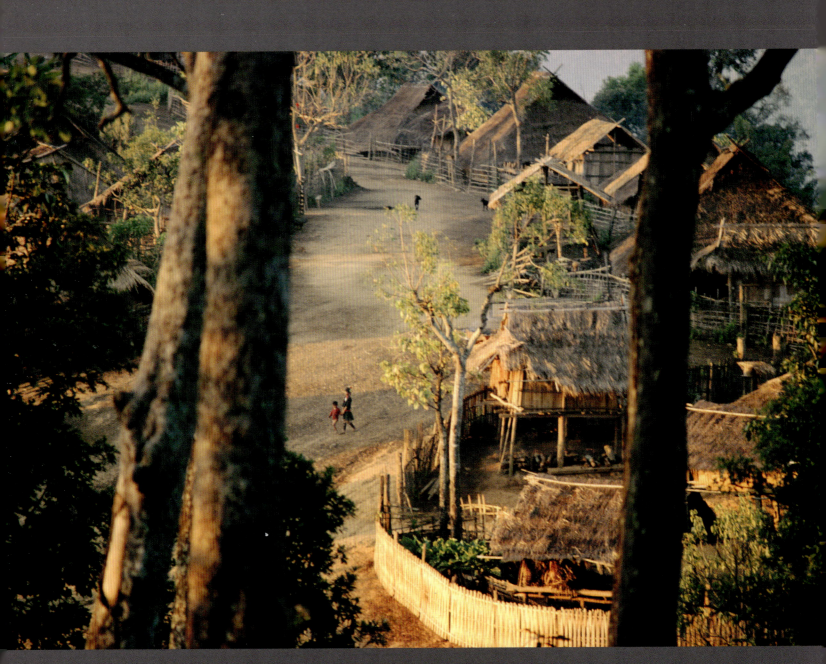

▲ Maw La Akha village, Chiang Rai, Thailand, 1980

LOOKING THROUGH

▲ Blurred foreground tree trunks are key to the subjective feeling of looking through. A moment later and the figures in a slightly less organized position.

F or most people, not necessarily just photographers, a viewpoint suggests a good view, meaning clear, and looking out over a worthwhile scene without obstructions blocking part of it. Scenic drives are punctuated by these, constructed helpfully by authorities promoting tourism. Clear views can become obsessive. Ansel Adams wrote at length about one overlooking Yosemite that he visited many times for its "marvelous vista," and how the camera position was limited. While all this is true and normal, there is another approach, which is to give the audience the subjective view of being there and coming across the view for themselves. This is what art director Lou Klein suggested I do for a book on an Akha hill community in northern Thailand, saying "I want to feel what it's like to walk down the hill through the forest and finally come upon the village." I obliged with this shot that deliberately uses unfocused tree trunks so that we know we're walking toward the edge of a forested slope and about to enter the village, waking at sunrise. Not a neat view, but more personal, and perhaps with more of a sense of place. A favorite of mine, in any case.

TUNNEL

I call it a tunnel effect because that's what it feels like, and even though this is simply the vignetting that is common from many wide-angle lenses, it has an effect not just on the brightness in the image, but also on the attention that the viewer will pay. Vignetting is a darkening away from the center, but because our eyes tend to look toward brighter areas, it concentrates attention toward the center. Lens manufacturers consider it an optical fault and engineer their lenses to minimize it, but some of us actually like it. In fact, it's very difficult to correct for in zoom lenses,

which is why processing programs like Photoshop have lens-correction modules. But you can always turn the vignetting correction off, or lessen it, instead of making it an automatic part of your processing. This is the SR-71 Blackbird, and over the course of an afternoon and evening I shot it from every angle and in several positions. This slightly weird, very wide-angle shot (21mm equivalent) from a close distance is hardly representative, and maybe not the best shot of the take, either, but the serious vignetting makes for a strongly concentrated image.

◄ A shift lens was used, and shifted upward to the maximum. This locates the center of the tunnel lower in the frame, and also exaggerates the vignetting above.

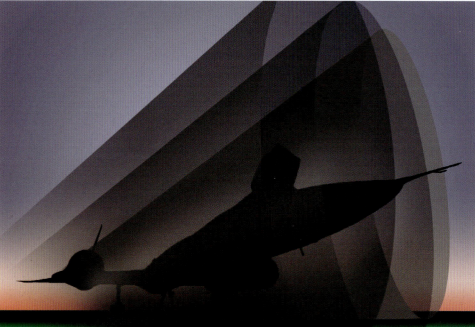

◄ The strong vignetting from the wide-angle lens gives a sense of looking down a tunnel, centered on the aircraft.

PRECISION

ost of the time in photography there are more important things going on in front of the camera than exact alignments—things like expression, action, gesture—but occasionally we go for a shot that inevitably calls for precision. The word "inevitably" sounds a little severe, but this example should explain. This is La Purísima Concepción Mission in northern California, and among other viewpoints and compositions there was this gate in a long adobe wall. Very simple, almost minimalist, especially in an early morning mist. And on the other side of the large courtyard, an identical gateway in the far wall. So was this inevitable? For me, yes, because from an angle the gateway would be skewed, and from any head-on position that showed the second gateway, if they were even only slightly out of alignment, it would look sloppy, as you can see here. This is what I mean by deciding on a shot that, whether you like it or not, pushes you into being precise to the tiniest degree.

▼ La Purísima Concepción Mission, Lompoc, California, 1991

▼ Even a slight shift of camera position away from the center line results in a noticeably sloppy composition.

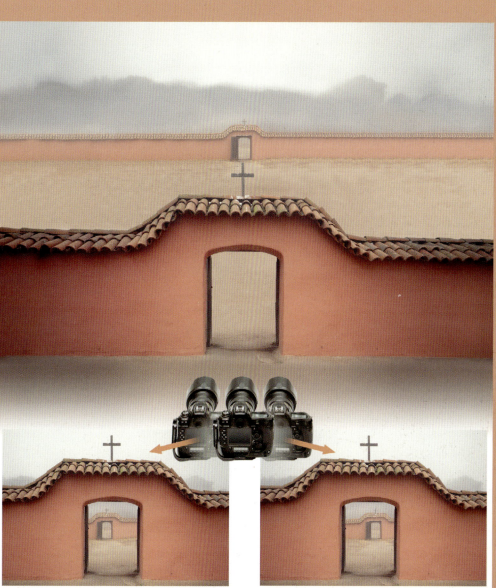

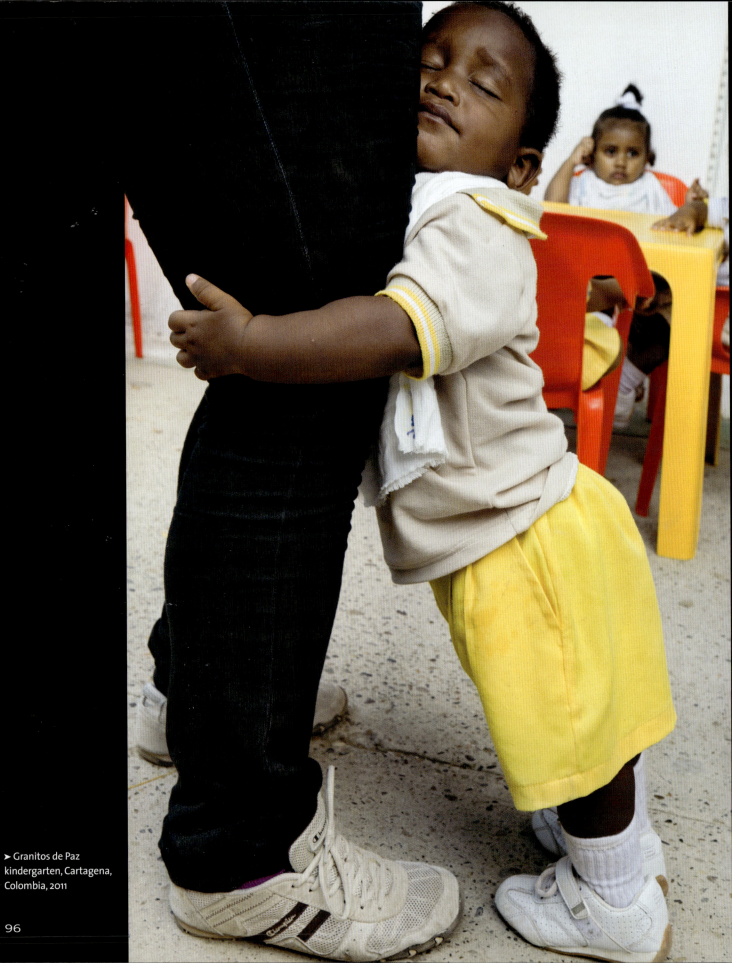

➤ Granitos de Paz
kindergarten, Cartagena,
Colombia, 2011

CLOSE

Not to be confused with close-up, which is more to do with magnification of small things, a close viewpoint means a sense of being right up against your subject. It also involves shooting from rather closer than most people would consider normal, perhaps even more than feels comfortable, but there are ways to make this an advantage. Often, there are practical reasons for a close viewpoint, and not just because there is no free room to stand back. There may be obstructions in the way, as any architectural photographer knows: photographing a building from across the street may take in unwanted telegraph lines or power cables, forcing you to move closer and use a wider-angle lens. But close is also by definition intimate, and this can be very good in the right situation, such as here, in a daycare center for young children. Right down at this child's level, and really close, there's a personal and emotional connection. Stepping back would have given a cooler, less involved image. Close viewpoints don't always mean wide-angle lenses; this was shot at close to normal (48mm) but tight framing helps the close effect.

▼ The outtakes, all less graphically clean.

▲ The camera position is evidently low, and this closeness is enhanced by the size relationship between the two faces.

DISTANT

There's an important difference between being far away from something and showing distance. I'm not splitting hairs. If the subject is far away, you can use a telephoto lens to bring it closer in the frame—a very functional way of dealing with the situation. If you want to see something more clearly, in more detail, you fill the frame with it and it's one of the prime uses of the telephoto end of a zoom lens. But what may be missing from the equation is a sense of distance. Only "may," because there are telephoto shots that do have a strong sense of distance; one of them is on pages 162–163. That works because the viewpoint is quite high—high enough to see mountains arranged one behind the other, with

aerial perspective (haze) playing an important part. In other words, it doesn't depend so much on the lens. What it depends on instead is a set of visual clues that show the viewer the distance between us and the subject. Here in Big Bend National Park in Texas, this view of the distant Chisos Mountains was shot with a wide-angle lens—large format, but the equivalent of 21mm. The viewpoint is slightly raised so that we can see from the foreground all the way to the mountains. Also at work is the framing, taking in a lot of sky. Quite an interesting sky, but the point is, with all these different clouds, it's a sky that shows distance by towering over the mountains.

➤ Being able to see all the ground between the camera and the mountains contributes to the sense of distance, as does the height of the clouds.

▼ Chisos Mountains, Big Bend, Texas, 1978

PART 6
OPTICS

Optics are not only what make photography possible, they also give images some unique characteristics not normally found in other media. If you want to indulge an obsession for equipment, I'd suggest that you're always better off lavishing attention on the lenses, because their style and quality deeply affect the image. Deep, in fact, is one of the first things that comes to mind with a camera lens, because the aperture is responsible for the sense of how far the viewer is allowed to see into the scene. The opposite, shallow, is possibly even more special, because a gradient of focus, from sharp to blurred, is a purely photographic phenomenon, as explained in the following pages. The visual elements in this chapter all come from the lens.

▲ Ta Prohm, Angkor, Cambodia, 1989

DEEP

Depth of field is one of photography's most useful qualities, because it determines how much of any scene appears sharp, and it's controllable. The first control is the aperture—stop down for more—but it also involves choosing the lens focal length. The wider the angle, the better chance you have of making absolutely everything in view pin-sharp at a small aperture. However, focal length and aperture are only tools for helping with the idea of deep, as seen here, in one of Angkor's ruined temples. The idea is pulling together the different scales of a scene into one image, from the leaves and texture of an ancient sandstone bas-relief that are only inches away, to the temple galleries that stretch into the distance, even through the far gateway. So, suitable close and distant subjects together are important, which means finding an exact camera position. Next is positioning the camera as close as possible for the depth of field at minimum aperture to just cover the range. The focus point for this is not exactly in the middle, but slightly nearer to the camera.

▼ The plane of focus (red line) is about a third of the way into the scene, to maximize depth of field at a minimum aperture (top pink shading). At a wide aperture, the depth of field (lower pink shading) would cover neither the foreground nor background.

IMPOSSIBLY DEEP

The laws of physics set limits to the depth of field possible with any particular lens. It doesn't help the photography much to get into equations, but one occasion when you really notice these limits is in close-up. Practically, the closer you get to macro, the less depth of field you can expect. You may not want depth of field—see the following pages—but if you do, you can't have it by normal means. This still life is not an extreme close-up, and yet there is no way to get front-to-back sharpness with a normal camera lens. So what about extraordinary means? One of the convenient things about digital photography is that you can combine images digitally, as in stitching and HDR, to name just two obvious ways. Slightly less obvious, but very smart, is focus stacking, in which software takes a set of photos all shot from the same position, but each focused at different distances, from close to far, and chooses the sharpest bits from each of them. It's not infallible, because the scale changes as you change focus, but it's pretty good, as seen here.

▼ Pen and book, 2012

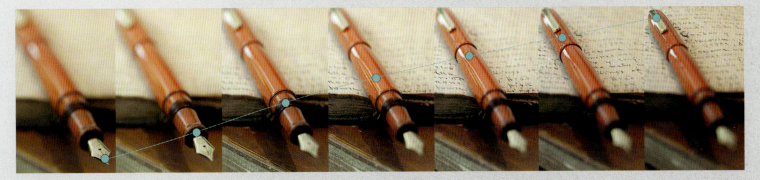

▲ Key frames from the sequence of 30, selected to show the progression of the focus point from nib to cap.

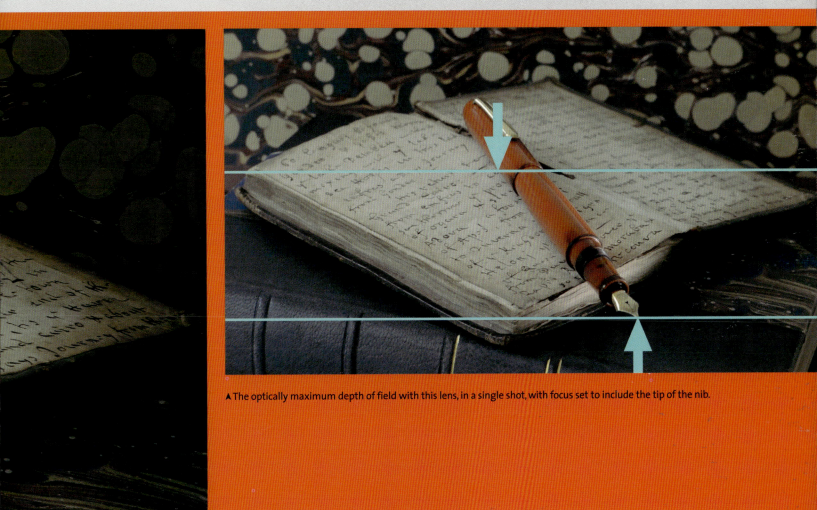

▲ The optically maximum depth of field with this lens, in a single shot, with focus set to include the tip of the nib.

SELECTIVE

Shallow depth of field gives selective focus, which means pointing the viewer to exactly what you want them to see, because our eyes cannot help but drift toward whatever is sharp. The wider the aperture, the more selective the focus, and this is where fast lenses come into their own. The aperture here is $f/1.4$, and with a subject that goes deep away from the camera, like this young maple tree, most of the image will be blurred to one degree or another. This is is optical blur (forget boke/bokeh for now, which is Japanese for blur and typically used to describe the subjective quality of blur rather than the objective quantity of it), and is special because normal human eyesight does not experience it. We see things at the periphery of vision as indistinct, but not blurred. This very optical blur gives images like this their visual appeal, so that

▲ Young maple, Tokyo, 2001

what is not in focus is every bit as important as what is. The choice of exactly what to focus on is critical, and the result is a kind of layering, with the small sharp areas superimposed on the soft wash. If the color is notable, as here and on the following pages, it adds another level.

▲ Selective focus works on the eye by sharpening the difference between a tiny sharp area and a larger blurred background.

▲ The difference in sharpness effectively creates different perceptual layers.

▲ Quartz crystal and abalone, 2012

COLOR-WASH BACKGROUND

Selective color from shallow depth of field means that most of the image will probably be blurred, and this can be turned to an advantage in one special way—with color. There are times when color will definitely enliven an image, and times when it's less important what those colors actually represent in real life. Here is one case: a macro shot of a small quartz crystal, and colors introduced from something that had nothing to do with it. Being quartz, it is colorless, but it also refracts, so it seemed natural to introduce color in the background. Shooting with a macro lens and fairly wide aperture (just enough to keep most of the crystal in focus), I placed a polished abalone shell several inches behind. The iridescent blue and green of the shell made an abstract play of color that I could also make refract through the crystal's facets. In fact, at this distance behind and softly blurred, the shell is made completely abstract and unrecognizable for what it was.

▲ The polished abalone shell, to be used for its iridescence alone.

▲ Close-up of the shell used for the background.

▲ Positioning the shell far enough behind to blur completely.

▲ Adjusting the reflections and refractions.

COLOR-WASH FOREGROUND

Blurred flowing color behind the subject you focus on may be the most common way of doing this effect, but something very similar is possible with an out-of-focus foreground. The shooting style, however, is quite different and not so obvious. It involves shooting through gaps or around the edges of a colorful subject close to the camera, while focusing on something distant. And it also means keeping the blurred colors of the foreground dominant, so this is not a natural shooting technique. Here, the location was Fatahillah Square on a busy weekend in Jakarta, Indonesia, and I was looking for ways of shooting the sidewalk food stalls—people at tables and the vendors with their bright mobile carts, each with glass cases full of noodles and other foods. Looking for a way to combine both, and having experimented only a little successfully with reflections in the glass cases, I decided to shoot through the glass to the people sitting beyond, at full aperture (f/2.8) with a 200mm telephoto. It involved a lot of moving around, not least to get the right amount of blur, which depended on how close I was to the lettering.

➤ The shooting sequence.

▼ Fatahillah Square, Jakarta, 2012

▲ Detail of the noodle vendor's glass case.

▲ The degree of blur depends on how close the camera is to the lettering.

TILT

If you photographed in pre-digital days and used a large-format camera, you knew the Scheimpflug Principle. Sounds daunting and takes some getting used to, but basically, the front part that held the lens and the back part that held the film did not have to be fixed and parallel to each other (which they are in almost all cameras). In a normal camera, if you change focus, the sharpest areas are simply nearer or farther away, and depth of field goes from near to far also. Not so if you tilt either the lens or the back. The plane of focus, which you can imagine as a sheet of glass upright in front of and facing you, tilts away as you tilt the lens forward. Why? Because what you may want sharp in the image isn't necessarily from near to far at a perpendicular angle to the sensor. It might be at an angle, such as objects on a table, or a flat landscape. There are a few specialized lenses that do this for DSLRs, so you no longer have to use large-format film. This is really one case where it's fairly easy to use once you get your hands on the equipment, but becomes difficult to describe in words, so I'll let the illustrations tell the story.

➤ Tower shell, 2012

▲ No tilt and maximum aperture.

▲ Tilted, maximum aperture.

▲ Un-tilted, the lens plane (orange) is parallel to the sensor (green) and the plane of sharp focus (yellow). At this point, these three planes never intersect.

▲ Tilting the lens forward tilts the lens plane. According to the Scheimpflug Principle, where the lens plane meets the sensor plane (lower right corner) is where the plane of sharp focus also has to meet, resulting in a depth of field that is wedge-shaped.

COUNTER FOCUS

The forward tilt on the previous pages is a solution for improving the subjective impression of sharpness in an image, but as we saw in Selective and Color-wash earlier, on pages 106–111, you might want the opposite. The tilting lens can help here too, if you put it into reverse, so to speak. I call it counter-focus, though that's just my term for it. Tilt back on a scene that is tilting forward, and you can get the most extreme selective focus possible—with the aperture wide open, naturally. I wanted to do this here, in a scriptorium where scribes were working on a handwritten bible, because I wanted to focus entirely on only some words. It's a standard focal-length lens, tilted right back; and for good measure, as I was using 4x5-inch film in a studio camera, the film back is tilted far forward. This is the exact opposite of the way these cameras were designed to be used, but camera manufacturers can't always guess what photographers will do.

▼ St John's Bible, The Scriptorium, Wales, 2000

▼ Tilting the lens upward runs counter to the lie of the drafting table, so that the scene is sharp on only a few letters and the hand. The principle works for both a tilt lens on a DSLR and the more traditional tilting front and rear standards of a view camera.

➤ The traditional way of doing this is by tilting the front and rear standards on a studio view camera.

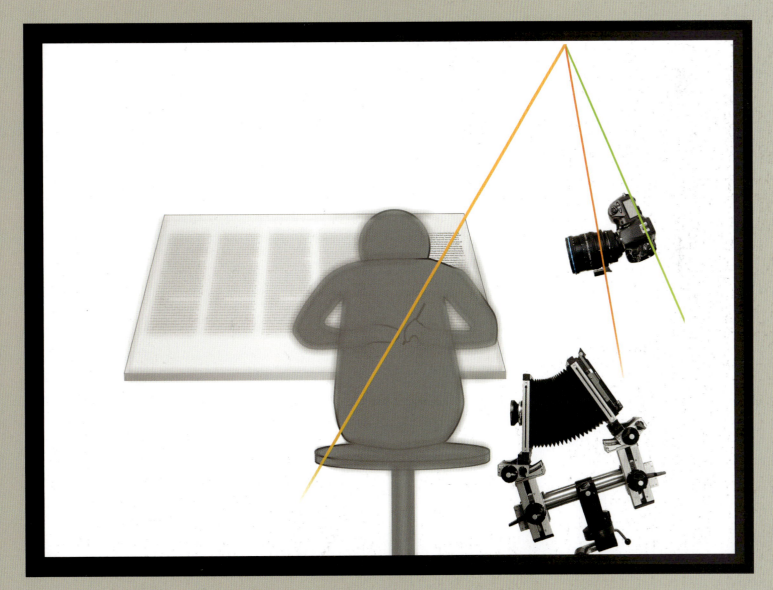

SHIFT

A shift lens, otherwise known as a perspective control lens, or PC for short, borrows from the same camera manufacturing ideas as does the tilt on the previous pages. In other words, it came originally from large-format cameras, which were big enough to be able to move around the front and the back (known respectively as the front standard and the back standard). Shifting is actually a simpler operation, both mechanically and optically. The lens slides up, down, or sideways, but stays in the same plane. This slides different parts of the scene into the frame, but it depends on having a lens that projects an image circle larger than the sensor. This is not something that normally concerns camera manufacturers or photographers: All you need is a lens that projects an image just on the frame. No more, no less. But imagine a lens that covers quite a lot more. Ordinarily, this would be a waste of optics, but not if you shift the lens. Its main use is in architectural photography, to avoid the issue of converging verticals, because from ground level, if you tilt the camera up to take in the building, the sides will lean inward. With a shift lens you aim straight, don't tilt, and then shift the lens up to bring the entire building into view. Yes, I know you can do this digitally in post-production, but isn't it better to do it for real on the spot?

➤ In use, the camera is first leveled, which cuts off the top of the church and shows unnecessary foreground (lower circle). Shifting upward restores the view without converging the lines of the building (upper circle). In order to be able to do this, the lens has a wider coverage than the sensor.

▲ A geared lever on a shift lens shifts the lens elements upward.

◄ San Xavier del Bac Mission, Arizona, 1991

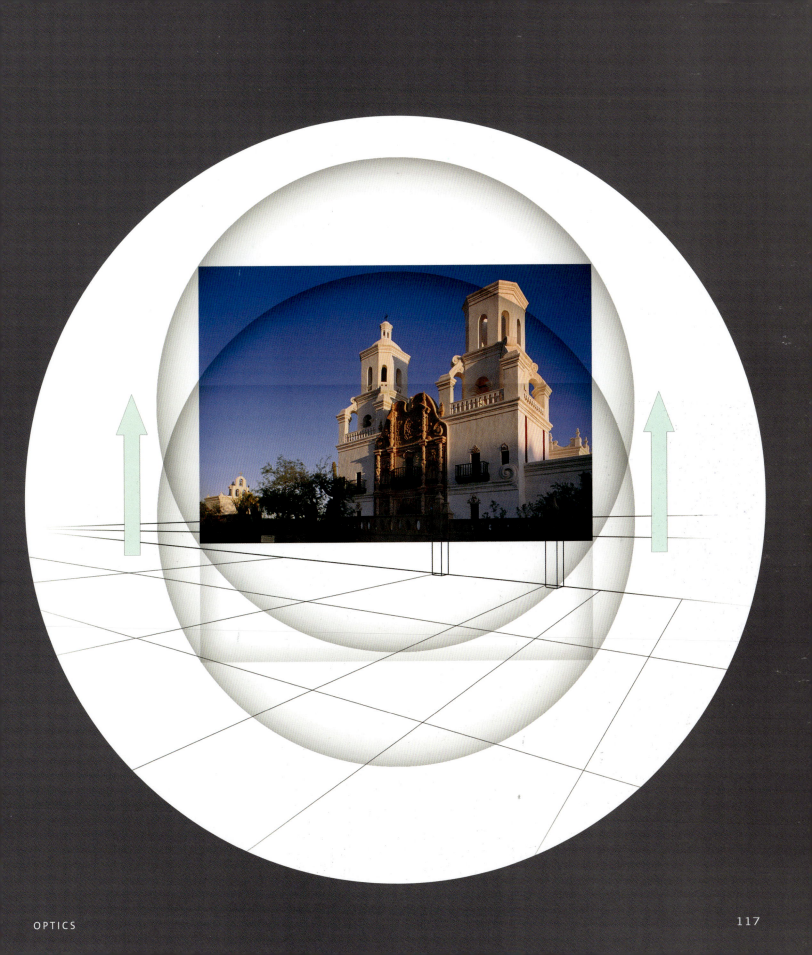

WIDE-ANGLE IMMERSIVE

Wide-angle lenses take more in from the scene. If you're backed into a corner and still can't get all that you want into the frame, you use a wider focal length. Simple. But using a wide-angle lens just functionally like this is to miss out on a more interesting effect. Lenses aren't just about optics, they can also deliver sensation and impression, which ultimately will get you more attention from an audience. I'm not going to start talking about how human vision differs from lenses and photographs, but if you use a wide-angle lens from close, right in the thick of a busy scene, you're doing what's called "subjective camera." In cinematography, this means taking the viewer into the experience of things, saying in effect "the camera is you." The idea is to project the audience into the scene so that they're immersed in it and get the feeling of actually being there, not standing back and just observing. This is why close, personal, and wide-angle is so highly valued in street photography. Yes, you need to fire up the confidence to do it, but the results are worth the effort.

▼ Fishermen landing catch, Kovalam, Kerala, 1981

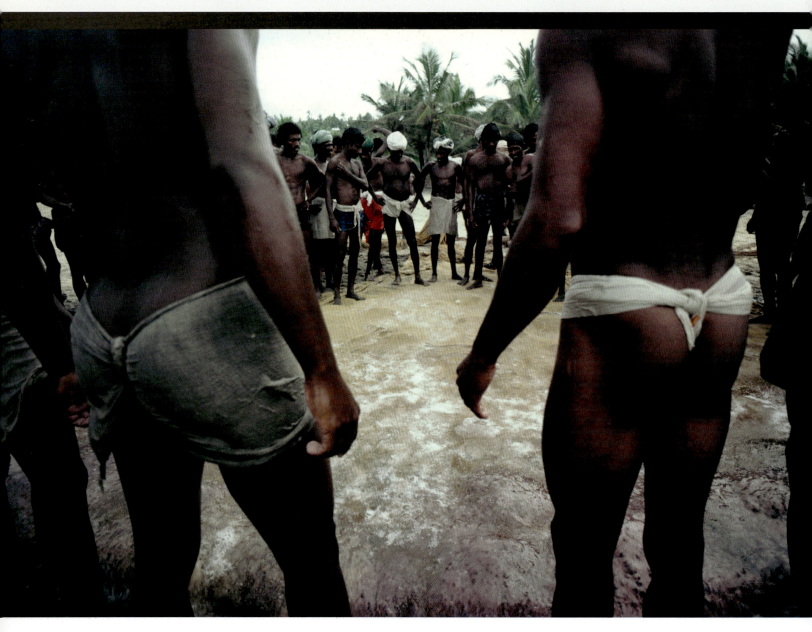

▲ Telephoto (400mm) from a distance.

▲ Telephoto (400mm) from the beach.

▲ Wide-angle (20mm) medium distance.

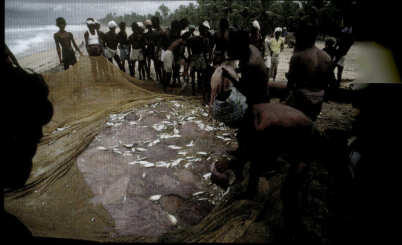

▲ Wide-angle (20mm) closer.

TELEPHOTO COOLNESS

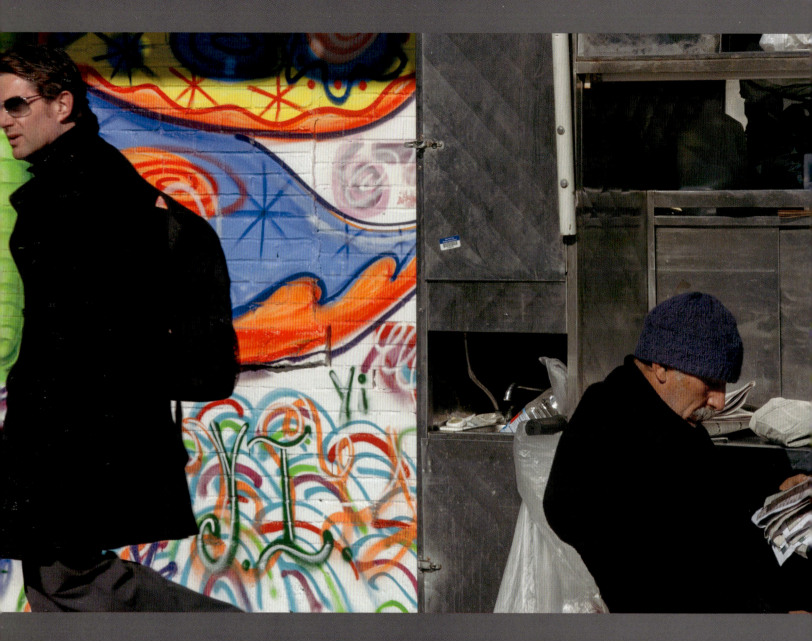

▲ Meatpacking District, New York, 2011

Just as you can use a wide-angle lens to push your way into a scene, you can also go in the opposite direction and step backward, switch to a telephoto, and be a fly on the wall—an objective observer. Some people see this as a defect of the telephoto lens (as in street photography, just mentioned on the preceding pages), but it's really a matter of mood and personal taste. Not everyone likes being thrust into other people's faces, and if you want to stand across the street and quietly observe at your leisure, perhaps drinking a coffee in a sidewalk café, a telephoto lens is the way to go. In fact, I used to call my old 180mm lens my "across-the-street" lens. Don't pay any attention if someone criticizes you for being too shy to get close, as tends to happen among street photographers. Cool, distanced moments are just as valuable. Some photographers, Jay Maisel for example, made a career out of telephoto perspectives, and it's all about the character of an image and the sensation you put across, rather than the more blunt "just get closer." In this New York shot, depth of field covers everything, so that it all appears to be on a similar plane—another telephoto characteristic.

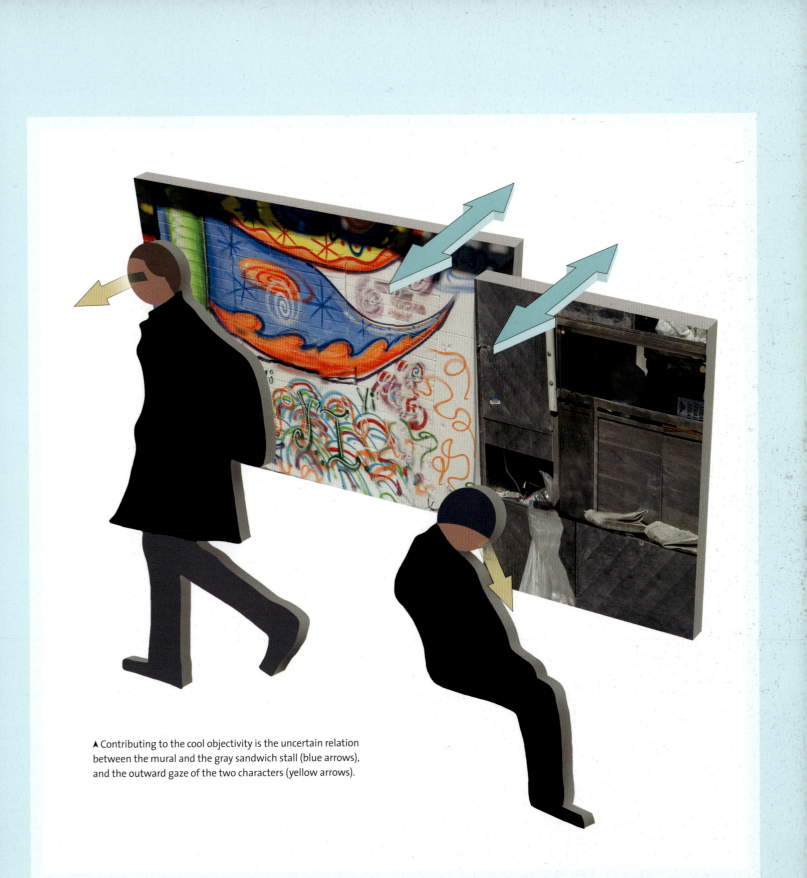

▲ Contributing to the cool objectivity is the uncertain relation between the mural and the gray sandwich stall (blue arrows), and the outward gaze of the two characters (yellow arrows).

PART 7
MOTION

Early photographers had a complex about movement, because the light-sensitive emulsions they used responded poorly to light. The very first photograph, taken by Nicéphore Niépce of some rooftops in 1825, needed an eight-hour exposure, in which time the sun and resulting shadows had moved so much that the image seems bathed in a strange light. Every movement in every picture situation has a shutter speed that will capture it sharply, from the blink of an eyelid to a galloping horse's hooves. This is always useful to know, whether you want to stay on the sharp side or go for the more impressionistic treatment of motion blur. More than that, however, when we see something moving in an image, our eyes and minds start to make assumptions about where it's going and how fast, as we'll see in the following pages.

FREEZING

Sports photographers probably know more about this than anyone else, because success often hangs on getting the key bit of the action, like a ball, frozen sharp, as well as in position and in focus. It's a matter of shutter speed, naturally, but different actions call for for different shutter speeds, and for all the calculations that will tell you what needs what, only the experience of shooting often is of any real use. In the exposure triangle of shutter, aperture, and ISO, there is always a trade-off, and a fast shutter speed may come at the price of noise or shallow depth of field. In this image of a Keralan fisherman hauling in a net, the straining movements of his body were not the issue. A modest shutter speed would have dealt with them. The key is the spurt of sand, frozen at 1/500 second by his feet. It catches the eye because it's sharp and slightly unexpected, and makes the shot. At a slower shutter speed, the image would still have worked to an extent, but without that extra finesse.

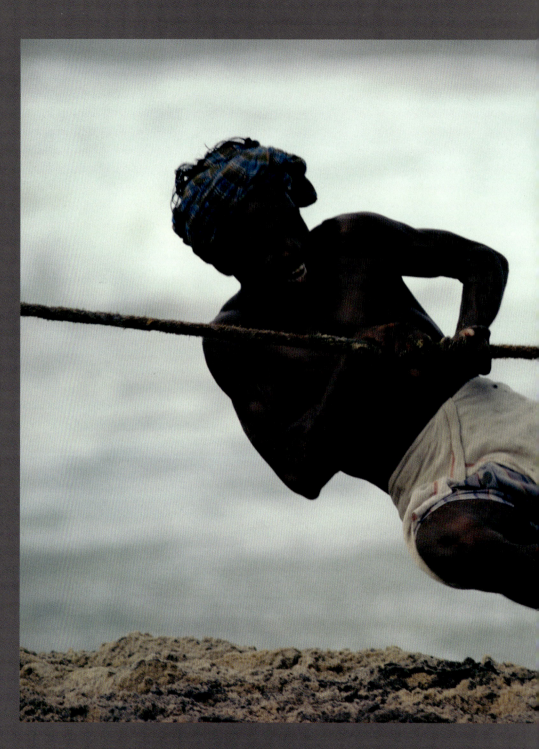

➤ Fisherman hauling net, Kovalam, Kerala, 1981

▲ Without the spurt of sand, the immediate focus of attention is the torso.

▲ The spurt of sand, simply by virtue of its being crisp and airborne, draws the eye down to the man's feet.

MID-AIR

In Chapter 2 there was a special kind of framing that I called "Just." There's an equivalent in the world of photographing action, and it's all about precision timing and knowing the exact position of a subject that's on its way through the air. I've always thought there are two good possible moments in a trajectory. One is when the thing is just about to reach its destination (an object crashing to the ground, for example), and the other is the "still point." They work in different ways, but they both share the mid-air idea. The first of these happens often, and to show its variety, rather than the more predictable vase-about-to-shatter-as-it-falls I'm showing a piece of food on its upward journey to a mouth. Well, if you chose to do this shot, what moment would you have chosen? The second shot is the exact still moment when something thrown into the air pauses before falling back, and the trajectory is a parabola. Here, not a ball, but a child—a member of a traveling Indian troupe of acrobats. For all the effort, you might think it would get more attention from the passersby.

▲ The mid-air moment in an upward trajectory.

▼ Sandwich shop, City of London, 2012

▲ Things thrown in the air follow a parabolic curve a very steep one in the photograph), and the peak is the still-point.

▼ Street acrobats, Mysore, 1981

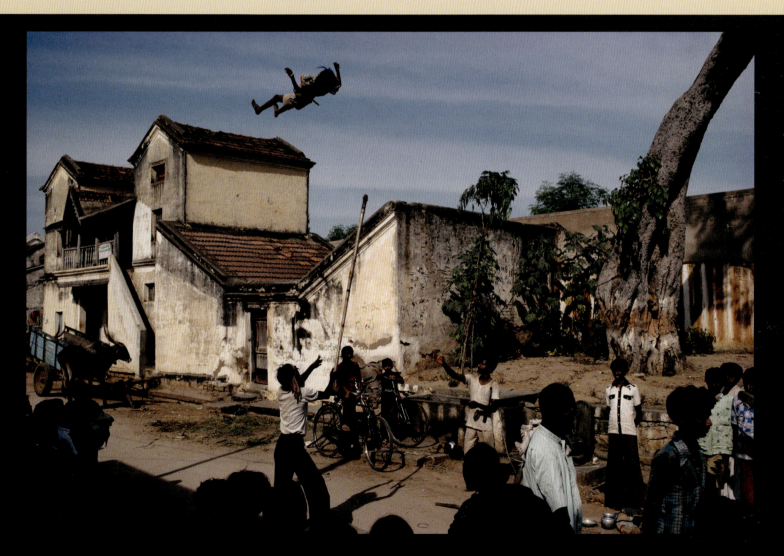

STREAKING

Also known as motion blur, this is one kind of photographic fuzziness that is thoroughly accepted by viewers, and is almost never rejected as being some kind of mistake (the same can't be said about out of focus). Here is almost the entire practical range in one repeated action—a girl on a bike cycling across the field of view. The shot, using a 200mm telephoto, was panned left to right, which comes naturally, and simply means keeping the subject more or less in the same position in the frame. At 1/1000 second everything is frozen sharp, but as a slower and slower shutter speed is set, the background begins to streak. The girl and bike stay fairly sharp all the way down to about 1/10 second, although some bits that move in different directions (her legs, the spokes) blur more easily. Is there a best shutter speed for this kind of thing? No, it's just a matter of taste and the balance you want to strike between clear information and impression.

▲ 1/1000 second

▲ 1/125 second

▲ 1/10 second

▲ 1/3 second

◄ Two kinds of motion blur, horizontal and radial, are involved here. The shutter speed is slower from left to right.

▲ Girl on bicycle, Kensington Gardens, London, 2012

▲ Barrio San Agustin, Caracas, Venezuela, 1978

MOVING IN

It's a fairly common situation. There's a scene, a setting, and for one reason or another it is appealing, but it really ought to have some life in it—a figure to complete the scene. The figure is easy enough to imagine, but life isn't always so cooperative. The answer is to settle down and wait, for as long as you feel the image is worth. Actually, that's just the first part of the solution. The next part is deciding where exactly a passing figure would best fit into the scene. And if it's someone walking through, there is a choice. As it happens, the most natural-looking position is on the side of the frame from which the figure enters, not in the center, and there's a reason for this. Because the walking figure is obviously moving, we assume the movement will continue, and so project the figure in our minds a little bit further forward. In other words, we sense that the figure is a little further into the frame than it actually is. This kind of placement is not compulsory, of course, just natural.

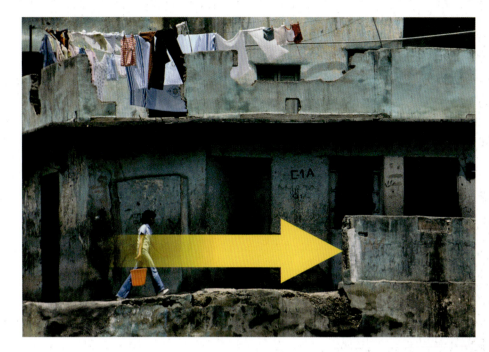

▲ The walking figure adds a vector to the image, and is also projected forward in the viewer's mind.

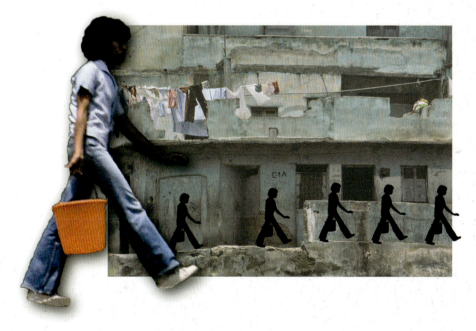

▲ Different choices of placement.

MOVING OUT

As with everything to do with composition, there's always an opposite to the expected and sensible way of putting an image together. If the natural way suggests a figure moving into the frame, why not have one moving out? Pulling the viewer's attention away from where it might think it wants to go can be an effective way of keeping the interest alive. Here, we're in an English seaside resort at the end of the day, and of the 21 frames shot, this is the one I liked best, partly because of the nicely curved stance, and also because the movement of the girl out of the frame made it different from the expected inward-facing, drawing-attention-into-the-frame versions. There's some logic at work here, because the lit façades of the harbor-front buildings give a clear impression of facing towards the setting sun, so the figure of the girl helps to complete the sense of the whole image being directed towards the right.

▲ Torquay harbour, Devon, England, 2010

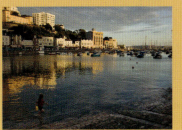
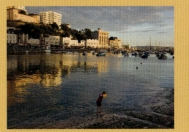
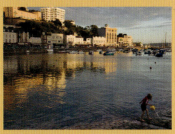
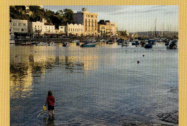
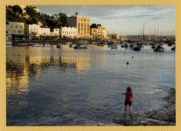
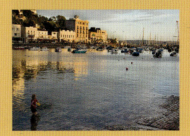
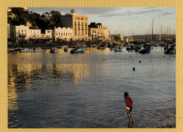

▲ The outtakes.

▲ The sense of the harbor-front facing right toward the out-of-frame low sun helps justify the position of the girl.

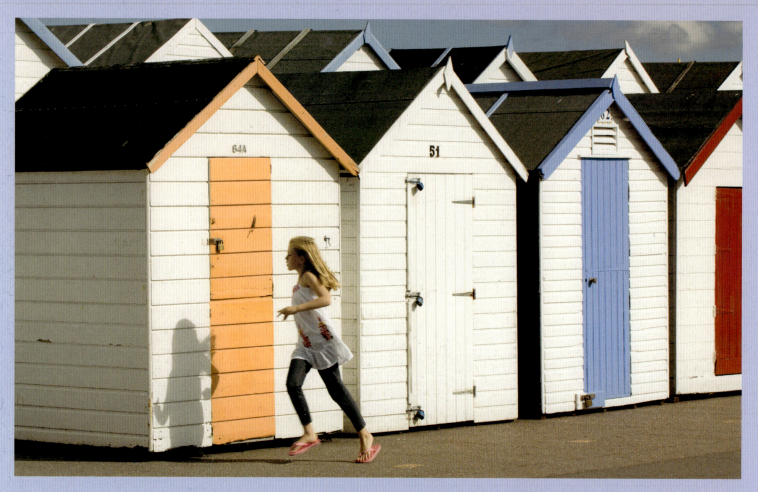

▲ Beach cabins near Torquay, Devon, 2010

▼ The outtakes, mostly unsuccessful because of poor positioning.

MOMENT

With any kind of motion, the actual moment is usually crucial, and it's often measured in hundredths of a second. With the last two examples, it was a matter of a scene and framing that had already been chosen; the variable was the figure moving through it. You can expect and anticipate how a figure will probably move through your frame, but it's rarely completely certain. In this case, the highly graphic setting of a row of colorful and traditional beach cabins in an English seaside town begged for a passerby to bring it to life. The best you can do in these situations is wait, and plan for one or two gaps within the composition where you'd like to catch a passing figure. For this to work, you cannot afford to let the figure cross over any graphic line, so catching the girl exactly in the white space was important. Most of the others were not at all successful. As the illustration shows, there were very narrow windows of opportunity.

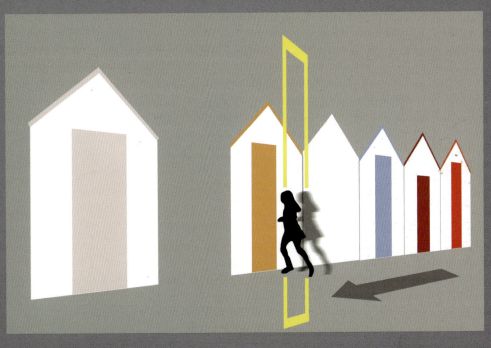

▲ Panning slightly with a 130mm lens, the shot was timed for the central of the three anticipated positions.

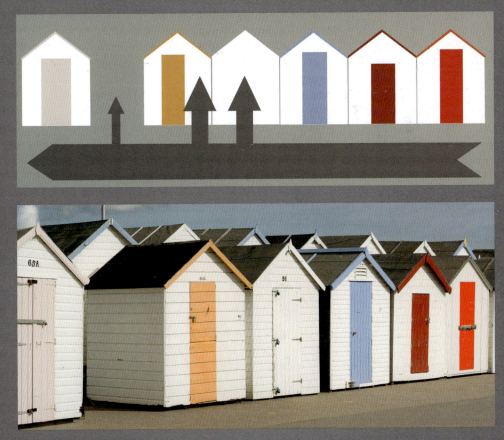

▲ The extended setting, waiting for a passing figure, with the three clearest positions for placing.

EYELINES

Humans are naturally curious, if not downright nosy. If we see someone looking intently at something, we want to see what it is, and our eyes follow the gaze. We don't want to miss out on the action, and if the person we're paying attention to suddenly looks up and away, that's irresistible. We can hardly help following that line of sight with our own eyes. Not surprisingly, it's known as the eyeline. And when two individuals are looking at each other, and the two eyelines converge, they become almost magnetically the center of attention. Incidentally, the effect is multiplied if someone is intently focusing a camera, because it suggests that the view, the subject, is really worth looking at. If it weren't for the fact that most photographers actively avoid including other photographers in their shots (yes they really do), we could invent the term "cameraline."

▼ The simple act of turning to look creates an eyeline in the mind of a spectator—we want to see what has caught her attention.

▲ Two eyelines converge and reverberate, drawing attention irresistibly towards this part of the frame.

PART 8
COLOR

Color is special, in photography as in painting, because the human eye and brain react to it in unusual ways. We respond to color differently from how we see other visual properties like brightness and contrast. Sometimes visceral, and even emotional. Color provokes like and dislike, and this reaction, strange when you think about it, gives it much of its power in imagery of all kinds. One of the great authorities on color, John Gage, says that "color has seemed to most of us to speak directly," an idea enthusiastically taken up in retail marketing and packaging. Everyone except the truly color-blind has an opinion about color, and this is something that photography can manipulate or challenge. Here are seven of what I think are the most distinct kinds of color relationships in photography.

RICH

Eye-catching means strong—in contrast, for example, and in color—and is a kind of instant gratification (and has its parallels in other sensations, such as taste and smell). Rich colors punch and are anything but subtle, and most people enjoy them, at least for a while. The word "rich" gets its meaning across well enough, but understanding it means knowing something of how we perceive color. The natural way for our eye and brain is by three qualities: hue, saturation and brightness. Hue is what most people simply call color (blue or red, for example), saturation goes from gray to intense, and brightness goes

from black to white. Here and on following pages, I'm showing color as a cylinder of hue (going round, like spokes of a wheel), saturation (from the center outwards) and brightness (from top to bottom). The upper section of this cylinder, from a top level of black, has been removed so that we can see inside to the medium-dark level. Rich means close to the outer rim at this level, here on a bathing ghat in Varanasi, rendered intense by the Indian love of strong hues. The final framing of the sequence aimed for maximum green-blue color, enhanced by the contrast with the brown skin of the man.

▶ The shooting sequence.

▼ Lal Ghat, Varanasi, 1998

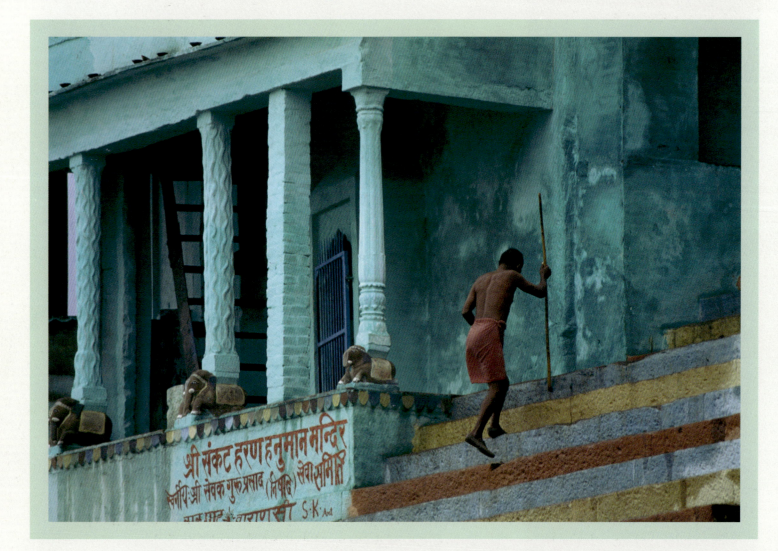

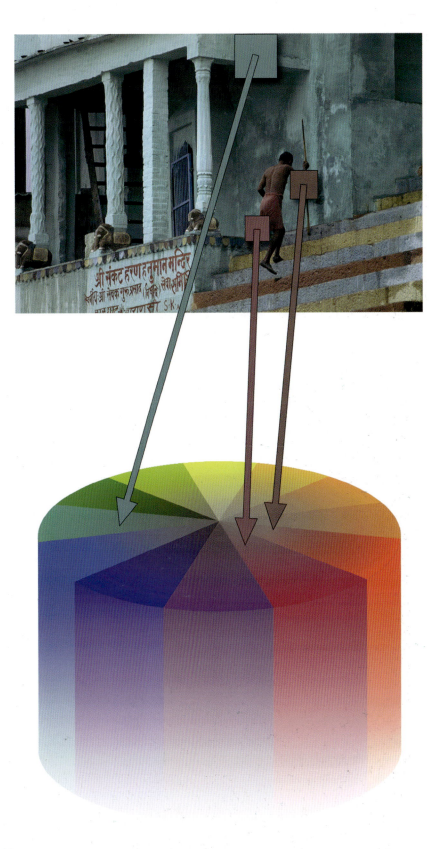

▲ The color cylinder has three axes: hue radially; saturation decreasing towards the center; and brightness from dark top to bright bottom.

PASTEL

For pastel, we have to slice down into the color cylinder to a lower, brighter level—whiter if you like. Here, we slide the lower section out and see these pale hues. That's the technical view, but for photography, we need to look for conditions like this one—a foggy day on a Pennsylvania farm, where the pale atmosphere softens all the colors. As you can see from the cylinder, the result is more about brighter than about less saturation, which was the case on the previous pages. The gray wooden building is certainly unsaturated, but the browns and the greens still have their colorfulness. Pastel colors can be just a part of an image, but here they suffuse the whole picture. A note about processing: the low dynamic range in a scene like this means that you have much more choice in how you process it without clipping whites and blacks, as happens with higher contrast shots. First note of caution is not to reach without thinking for the black-point slider. You can, of course, but an overall pastel scene like this keeps its character by not containing black!

▼ Farm, Pennsylvania, 2011

➤ Pastel colors are grouped in the lower, brighter part of the cylinder.

▼ The basic graphic elements.

▲ Shaker Meeting House, Sabbathday Lake, Maine, 1985

THE PHOTOGRAPHER'S EYE: A GRAPHIC GUIDE

MUTED

Rich colors, like strong flavors, hit our senses full on, but for the same reason that they give us plenty to react to, they quickly become too much for comfort. Visual excitement, which is what they deliver, works best for most people when part of a balanced diet—and this is where plainer colors come in. Here, we're back with the Shakers, last visited on pages 60–61 and for much the same reason. The entire subject of Shaker design and architecture revolves around their religious principle of simplicity, restraint and the avoidance of anything decorative. Shaker colors tend to be muted, and that worked best for the book I was shooting when the light itself contributed to the effect. In this case, a softly raining morning. The illustration shows how otherwise the autumn hues might have gone (increasing saturation outwards). You might ask what the difference is between muted and drab. The answer does not lie in the actual color scheme, but in our own value judgment. If you're in the mood for color pizzazz, then its drab; if you feel like restraint, it's muted.

➤ To show the amount of desaturation in the photograph from the soft gray light, each of the main colors is here expanded outwards to full saturation.

THEME

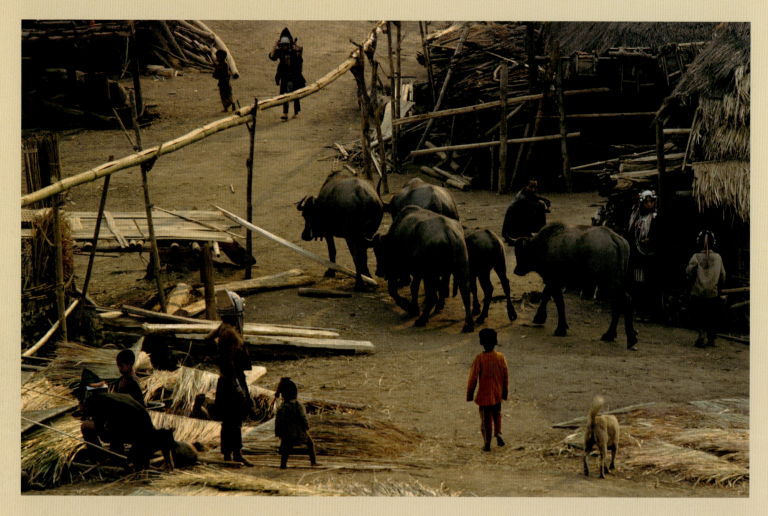

▲ Akha village, Thai-Burmese border, 1981

A color theme covers a number of images, and so works well for any picture story because it helps to hold them together and give them a sense of unity. It means working with colors that have similar hues, and on our color cylinder that means they lie on the same zone of the circle. Here, I've highlighted it by cutting a wedge out, like a slice of cake. The word "theme" sounds intentional, and while it doesn't have to be (you could simply select it from what you already shot), in this case it was. These pictures were part of the same assignment as the "looking through" shot on pages 90–91, and after shooting for a couple of weeks I realized that the Akha lived within a certain range of colors. The main picture here was typical—everything ranged around brown, from yellow ochre to brick red. Greens and blues were distinctly absent. Words like "ochre" and "brick" are understood by everyone better than HSB (Hue Saturation Brightness) descriptions, but they do mean mid-range brightness and medium saturation, so all these Akha colors come from one tight zone of the cylinder.

➤ Schematically, the colors have a consistent, earthy theme.

▲ The color theme comes from one segment of the circle—and the inner, less saturated part.

▲ Other images from the assignment, also with this common theme.

◄ Key elements of the color palette.

▲ Market day, Chimayo, New Mexico, 1994

PALETTE

Borrowing this word from painting, I mean a set of colors that has been chosen, one way or another, to bring a particular character and look to an image. For painters, however, it is an entirely personal decision, while photographers have to work with what is in front of them (although processing tools can help bend the situation towards what you want). If this sounds as if there's little choice in the matter, consider the color palettes associated with places and with styles. On the left is one example: New Mexico. Look carefully and you'll see that the state does have certain colors appearing time and again. Below are four pictures that are deliberately looking for these colors, and they're logical. First, there is a range of earthen color biased towards yellow, ochre and tan—from the desert and the adobe buildings. Then there are chilli peppers—who could miss those? But also blue-greens are a favorite—they make a bright contrast with adobe walls and also, perhaps, are inspired by the local turquoise. The tiles, incidentally, are art deco from the KiMo Theatre in Albuquerque, and very knowingly celebrate the New Mexican palette, while the interior is in the Mabel Dodge Luhan House in Taos. Let's put it to the test with a street shot. Farmer, chillies and old pickup truck are themselves characteristic of New Mexican life, and the colors, I think, hold up pretty well, too.

▲ The characteristic color palette of New Mexico, contrasting aquas with warm and earthen colors.

SPOT

Some people call this color accent, and it means a single strong color concentrated in a small area, dominating the picture because the surroundings are drab, muted, or at least a consistent—and different—color. This kind of situation is not particularly common, least of all in the visual chaos of cities, which are becoming more and more multi-colored. It, or at least the potential for it, needs looking out for. The key to making spot color work as an image is framing, because it's all about cutting out the distractions, and leaving just a single unit of color against a relatively colorless background. The framing technique depends on the situation, but two useful ways are finding a higher viewpoint (that cuts out the distance and horizon), and cropping in with a telephoto. In this example, from a river bank, I used a telephoto to exclude what was above and below, but then, seeing that sideways offered more of the same grayish background, I did a pan-and-stitch to widen the frame. Red is the most insistent and eye-catching of all colors, so I could place the woman way off near a corner and still have the image work. I also tried different framings. In fact, to my mind, the balance between small strong color and large gray background works better this way. As the smaller image on the opposite page, converted to grayscale, shows, the composition needs the spot color.

▼ Washing clothes, Daxi River, Ninghai, China, 2011

THE PHOTOGRAPHER'S EYE: A GRAPHIC GUIDE

◄ Alternative positions
in the frame for a less
colorful version of
the woman.

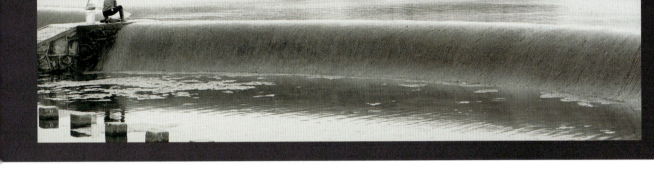

◄ In black and white,
the point is lost.

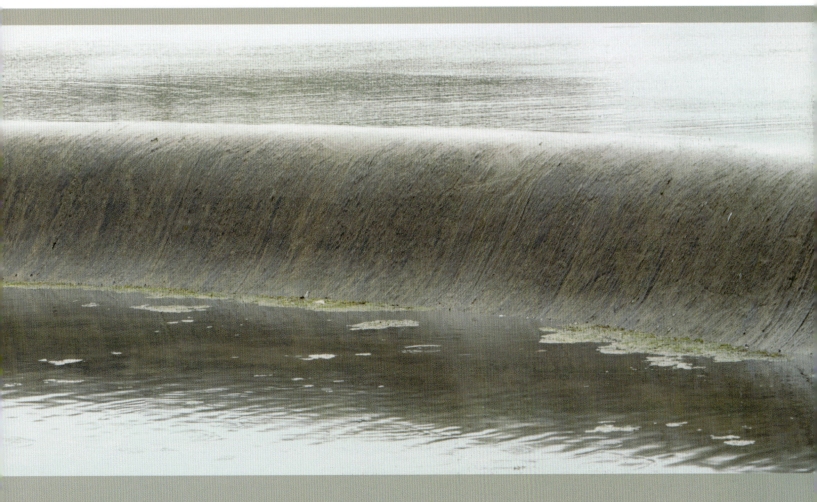

▲ Grand Prismatic Spring, Yellowstone National Park, 1978

CONTRAST

Much of the color so far in this chapter has been in some way similar, but in life the opposite is just as common—different colors in the same image. Going back to our color cylinder, what counts as different for our perception is actually just the hue and not the dark against light or gray against saturated. If a color theme, as on pages 146–147, is all from the same wedge of the circle, different colors are from opposite wedges. With the hues arranged around a circle like this, it's easy to see where the greatest contrasts are. Orange against blue, red against green, yellow against violet. Whatever is directly across the circle has the strongest color contrast. By no coincidence, these are also known as complementary colors, and this is not just a matter of opinion (stare at a patch of orange against a white background for a minute, then shift your gaze to the white, and you will see... blue). This remarkable sight, best seen from the air, is of the well-named Grand Prismatic Spring in Yellowstone National Park. The blue comes from the way water normally absorbs wavelengths, but is particularly strong here because of its depth and purity. The opposing orange is from pigmented bacteria.

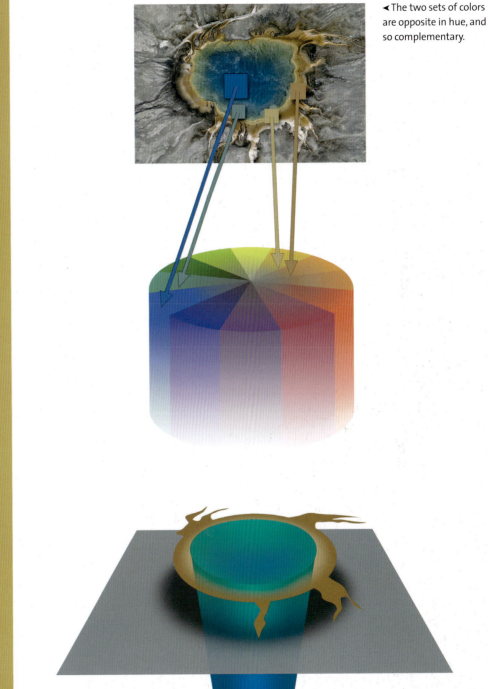

◄ The two sets of colors are opposite in hue, and so complementary.

▲ The blues and greens are from the normal elective absorption of light by water, but the surrounding ring is from pigmented bacteria.

PART 9
JUXTAPOSING

Juxtaposition—setting one thing against another in the frame—is absolutely basic to photography, and always has been throughout its history. Quite simply, it adds depth to the image—depth of idea, depth of graphic form. Often just one of these, but sometimes when we're lucky or just working harder at it, the two together. When it's about idea, the combinations are endless, and more often than not a subject in the foreground is placed against a subject behind with the implication that they have a connection. Often, and maybe even usually, they don't in reality have a connection, but that doesn't prevent the photographer from making a point. It's totally open to abuse, which is good, because it opens the doors to a whole range of ideas, from silly to thoughtful, and from clarifying the situation to introducing complications. It's a point of view in more than one sense, a suggestion that we make by positioning one thing against another and implying that together they equal something else. You can also make graphic forms coincide, and that strengthens the case, but ultimately it's still all about idea.

The lack of intention in this case doesn't refer to the photographer's, but to the participants in the scene. How could they be otherwise? Only the photographer can see the connection, or suggest the connection, through where he or she stands, and the framing and lens, and so on. These are the classic red British phone boxes introduced in 1935, except one of them is not what it seems—it is an entry in a London-wide display of "Artboxes" commissioned by British Telecom from different designers and artists. For a shoot on this summer project, I was deliberately looking for locations where I could juxtapose real boxes against the not-quite-real boxes. This was one good location, not least because this particular Artbox, at first glance, looks similar (many entries were nothing like the originals). I also had another note in my shooting script, something to hope for, which was to do with passers-by. Any of the pictures would be improved by having some form of interaction between a box and people, ideally if they were not simply being looked at as a curiosity, but it was unpredictable. This scene happened by good luck.

 Outtakes in the run-up to the final shoot, looking for viewpoint and moment.

▲ Telephone boxes, Marble Arch, London, 2012

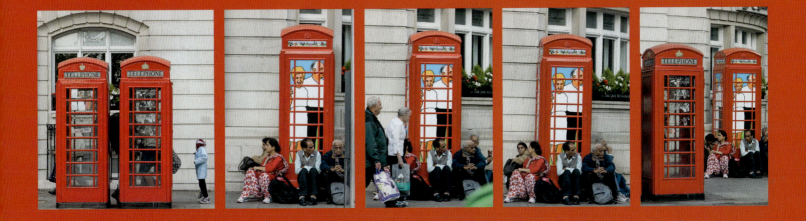

▲ Two juxtapositions are at work: between the two real boxes and the painted one, and between the real and painted people.

Ansel Adams invented the term near-far, and the idea is to include a very close foreground subject and another subject in the background, both impeccably sharp, and to show some meaningful relationship between them. He used it in his landscapes, and he was meticulous. Just slapping a rock in the foreground and a mountain behind doesn't do it. They need to compare in some way, either graphically or in meaning, or both. It's a wide-angle effect, naturally, which means that tiny adjustments to the camera position make a big difference. This is cormorant fishing on a lake in Yunnan, China, and I like this shot because first, it's the closest I've ever been able to get to a cormorant (inches), and second, you can see almost the entire process of the fishing in one go—including the fish in the mouth and the cord around the gullet that prevents the bird from swallowing. The detail, however, lies in the exact positioning of the bird against the boat and the man.

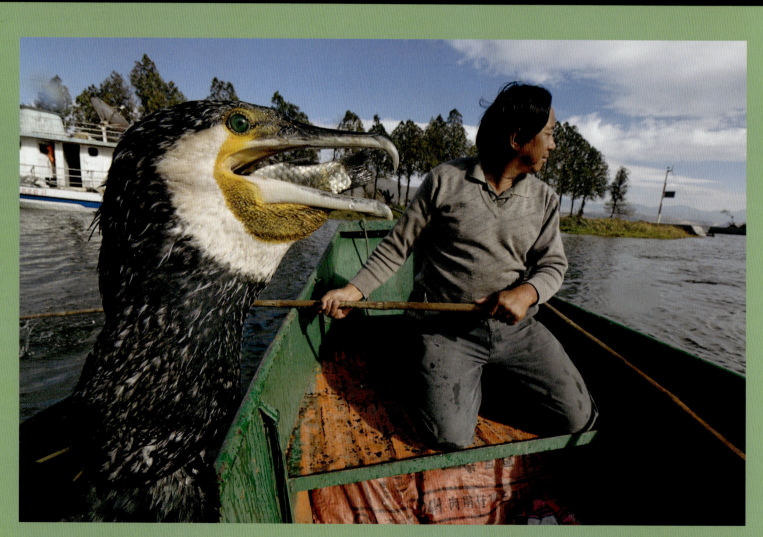

▲ Cormorant fishing, Erhai, Yunnan, 2007

➤ The final selected shot has the bird's head and neck neatly fitted against the edge of the boat and the man.

▲ Small shifts of camera position allow major changes to the position of the bird in relation to the man and boat.

COMPRESSING

I could as easily have put this in the Optics chapter, because it's very much a feature of using a telephoto lens, and the longer the focal length, the better. This is London's Millennium Bridge (better known as the "Wobbly Bridge" because it swayed with the heavy pedestrian traffic on its opening day and had to be closed until the engineers made it fit for purpose). From the south bank is the wide-angle view towards St Paul's Cathedral favored by television crews. By contrast, the view from the north with a seriously long telephoto—600mm—gives a classic compression. You have to be nearly end-on for this to work, but see how the bridge appears to be steeper than it really is, and how the pedestrian figures appear nearly the same size. Even figures on the far bank of the river become obvious, and indeed, the relationship between the people on the bridge and those in the distance helps to make the image.

▼ Millennium Bridge, London, 2012

▲ A more conventional, wide-angle view of the bridge from the other side.

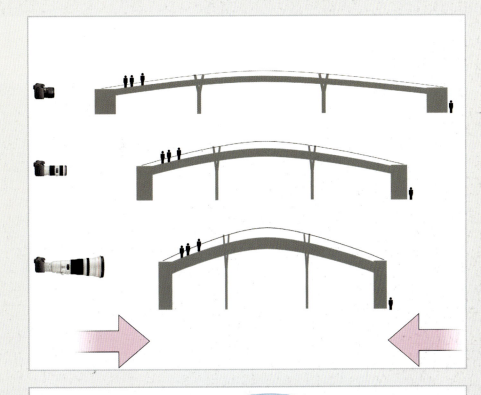

◄ A visual explanation of the compressing effect of a telephoto lens.

◄ Extreme compression has a strongly graphic effect, separating the mass of pedestrians and the bridge structure, and making both appear to be tilted towards the camera. In addition, the figures on the opposite bank appear nearly the same size as those on the bridge, and their relationship is an important part of the composition.

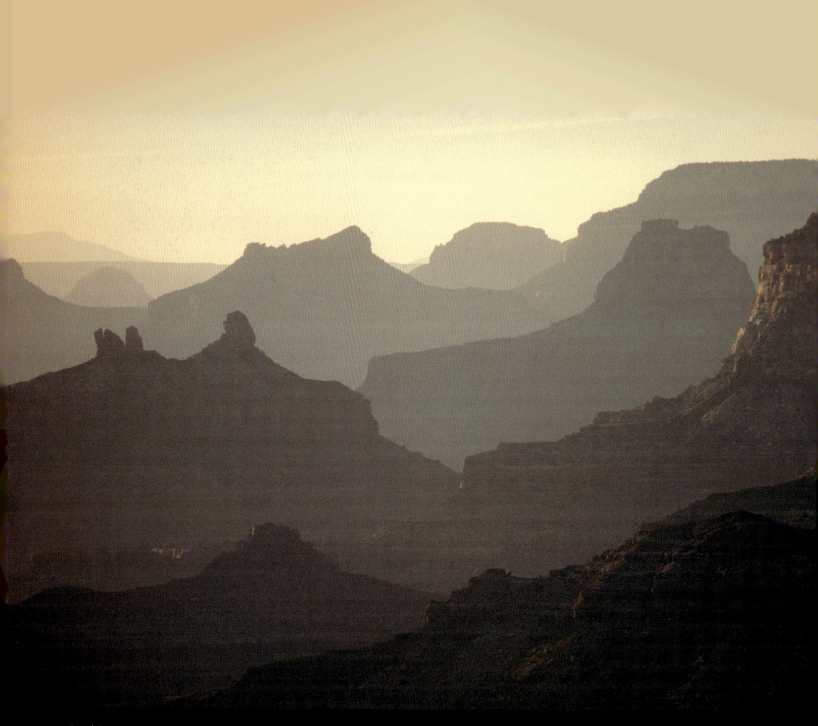

▲ Grand Canyon, Arizona, 1990

STACKING

With the right conditions, a telephoto—and especially a long telephoto—can give the effect of a stack of upright planes, like a pack of cards, arranged one behind the other. This is what is happening here in a shot with a 400mm lens down the Grand Canyon in Arizona. The stack in this case is provided by the series of bends in the gorge, but other things go into the effect: the viewpoint is high enough to see over each high rocky spur; the summer haze and backlighting hide the details in each plane and help to make them two-dimensional; while the compressing effect of the long focal length (see the previous pages) makes the rocky spurs seem almost equal in size. It's an abstracted kind of result, which isn't often possible with landscapes, so it is a welcome opportunity when it comes along. One more thing: everything needs to be in focus for this to work, and long telephotos need special care for this, which usually means a very small aperture—$f/32$ in this case—and so a slower shutter speed with the risk of movement from mirror slap.

▲ Lacking detail because of the haze, each outcrop appears as a two-dimensional cut-out.

▲ The distance visible down the canyon translates the scene into as many as a dozen planes.

LAYERING

Reflections of scenes add an extra dimension—literally, because they add their own surface details and irregularities in a separate layer. Irregularity was a special feature here, in Yangon's Shwedagon Pagoda. Mirror mosaic work in a very Burmese style adorns the pillars, and each small mirror is set at a slightly different angle. Close-up and focusing back through the pillar to the reflected view of the temple gave a disjointed and overlapping scene, but one that nevertheless has some recognizable parts. The golden stupas, of which there are several, are repeated in odd ways, and all that was needed was to find a camera angle that included one or two small figures to give it scale and set the context. It would have been possible to bring more of the pillar and its decoration into focus, with a smaller aperture and even with focus blending (pages 104–105), but that would have spoilt the merged overlaps of sky and stupas.

➤ Temple pillars decorated with glass mosaic.

▼ Reflections on pillar, Shwedagon Pagoda, Yangon, Myanmar, 2009

TABLEAU

▲ Lunch party, Cartagena, Colombia, 2012

This is a term from classical painting and theatre, and means, strictly speaking, a group of figures formally arranged to represent a historical scene. More generally, it's come to mean a set piece, an arrangement of things happening at a certain moment—perfect, or at least good and timely. The most famous of all—and let's get it out of the way—is Leonardo da Vinci's *Last Supper*. This image here is not a reference to that nor an imitation of it, but the interesting thing is that the *Last Supper* has become so iconic that almost any squared-up image of a long table with people sitting at it, talking, evokes some association at least. The situation here is simply lunch among friends, but the symmetrical arrangement, and the light, made me think of shooting it as the conversation became animated. I had time to put up the tripod, with no one paying any attention whatsoever, and because of the shape I wanted, I shot overlapping pairs for stitching, left and right. This gave me a choice of combinations, but the key to the shot is the contrast between the two furthest figures, far left and far right.

▼ ► The left and right choices of movement and expression.

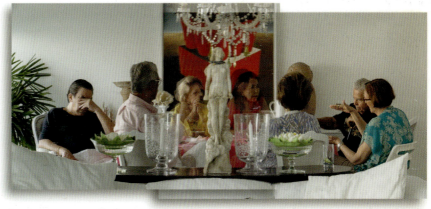

▲ The stitched composite.

SILHOUETTE

Silhouettes predate photography by a century, and began as black card cut-out portraits in profile (the cheapest way of making a portrait at the time). By their nature, they create two separate planes in a picture—subject and background—and rely entirely on this and on outline for their effect and success. Advanced digital processing makes it possible to open up shadows and recover detail which, while valuable for some images, has also created a kind of obsession among some photographers for revealing everything in an image. Well, sometimes you need to hold things back from the viewer in order to make the photograph more interesting, and a silhouette is one clear case of not wanting to see detail in the shadows. Underexposure is what works here, for a rich and saturated background. This odd silhouette is of giant concrete statues of figures from Hindu religions in a bizarre sculpture park. The scene works well in both clear morning light and backlit evening light, but the silhouettes at dusk have an extra tinge of mystery.

▼ Sala Keoku Buddhist sculpture park, northeast Thailand, 1989

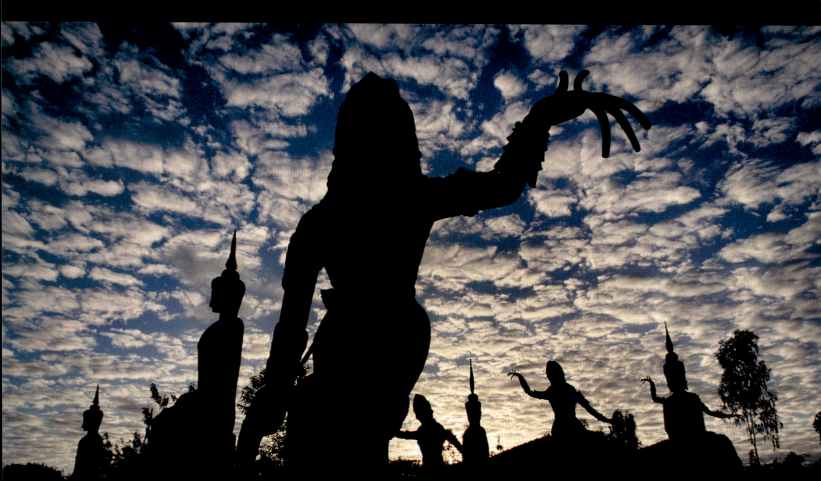

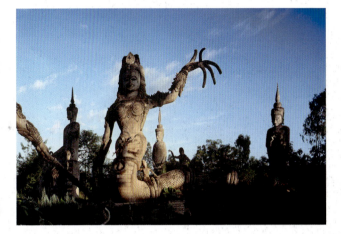

▲ Approximately the same view shortly after sunrise.

➤ A dense silhouette has the effect of creating two separate, almost two-dimensional planes.

ACTION COINCIDES

With busy scenes, one of the problems is finding a way to make elements cohere, to pull together in some way rather than seem completely haphazard. Sometimes the camera angle can do it, or the light, but often you have to rely on the way the action unfolds. Rely may be the wrong word, because things often don't work out, and you end up with just a busy scene. This is a South Indian temple, and here is a statue of Nandin, the revered bull of the god Shiva. There's also a live version wandering around, as cattle in India do. Could this coincidence make a picture?

I waited, tried a few things—people coming, praying, going. All mediocre shots. Then, briefly, the cow looked up at the statue just as one man reached down to touch its feet (an Indian gesture of respect) and another man reached up to touch the statue. The actions, all separately motivated, just came together and brought some order out of chaos.

▼ Nandin statue, Arunachaleswara temple, Tamil Nadu, India, 1998

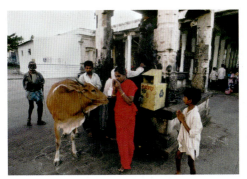

▼ The three coinciding actions added
to the eyeline from the statue.

▲ The outtakes, all lacking the unifying
effect of the principal image.

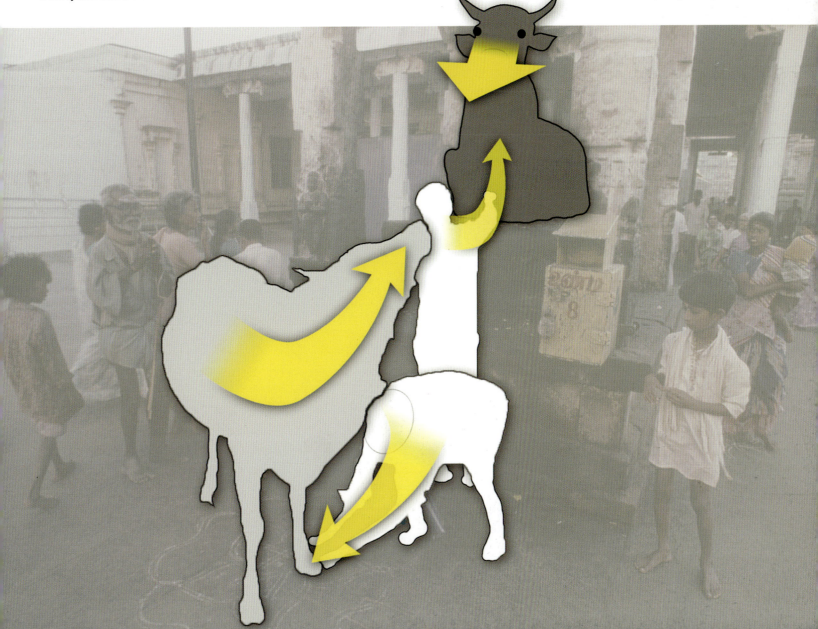

PART 10
COMBINING

Digital photography's Original Sin is the manipulation of what used to be called "reality." Seamless and faultless, this practice preyed on the naïve belief that photographs showed what was actually present. After all these years it still causes dispute and heated argument. Much of the dilemma hinges on what the digitally altered image is trying to do. At its most basic, is the photographer trying to fool people into believing that the image hasn't been manipulated? And even if the aim is fooling the audience, is the intention pure or impure? Pure in this sense means, for example, art, while impure means making money, or delivering the image that you originally failed to do all in one shot. You could go on forever with this debate, and it's not likely to be rewarding. Here, let's look at one of the major uses of digital manipulation: combining two or more images into one. Compositing, or "comping," in fact goes back to pre-digital days, and the aim is to combine different images so well that they appear to be a single image. The following images are all "declared" composites in that they don't pretend to be single, unadulterated photographs. Except one, possibly.

COLLAGE

A collage is an assembly of separate images, which you might think is really the job of an art director on a magazine or book rather than a photographer. The idea is that the different images are defined, and usually separated by their edges, which are left clear and straight. Nevertheless, by choosing the images carefully and by positioning them so that certain edges fit neatly against others, they can be blended in an almost seamless way. The viewer understands that they are separate, but at the same time they appear to make a whole, and the result is a kind of single picture. Equally understood is that the selection of images have something in common, which is why they are grouped together. This collage, made from existing images in the archive, is of London windows that each reflect a scene beyond them. So, each of the seven photographs is made of two layers, and in most cases works because the reflected view is sunlit. This suggested the idea for the collage, which is itself partly layered; in other words, layered images layered together. One technique used for this is the Layering mode, which for two of the images is Multiply, and for another two Lighten.

▲ Exploded view of the seven layers.

▲ London windows, 2011–2012

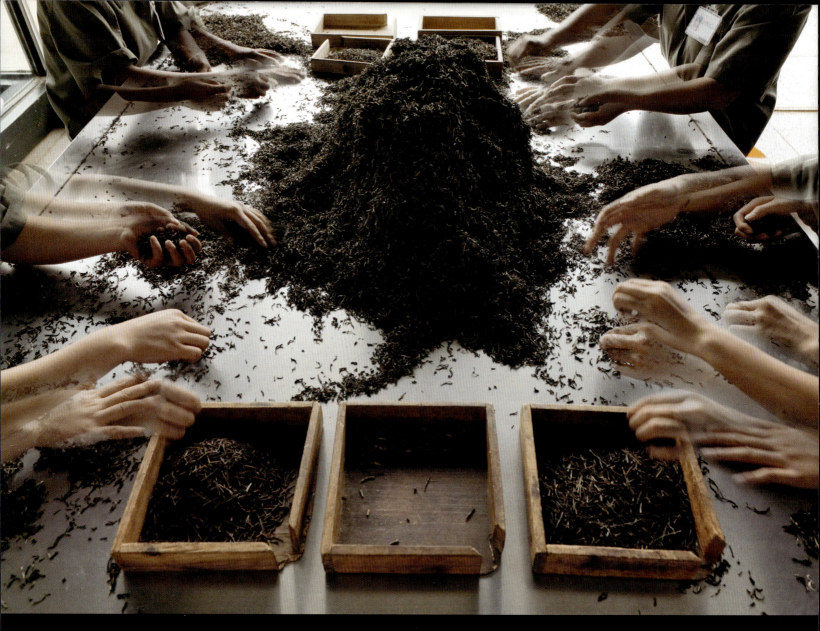

▲ Tea factory, Huiming, southern Yunnan, 2009

▲ The sequence of frames, from which the final comp was made.

STEPPED ACTION

A sorting table in a tea factory. As with many factory-industrial scenes, the photographer's problem is trying to escape the "annual report" look. I needed the scene for a book, but how to make it more interesting? In fact, the hand movements were deft and rapid; just watching the actions repeated over and over again was slightly mesmerizing. A cinematographer might have considered undercranking to give a jerky, sped-up treatment. To get something of this hyperactive flavor in a still image, I locked the camera on a tripod and shot many frames. From these I chose a-few-to-several positions for each hand and brushed them in selectively, using a stack of layers in Photoshop. From start to finish this took 144 seconds, so you could say that this is simply a still snapshot of a possible movie sequence.

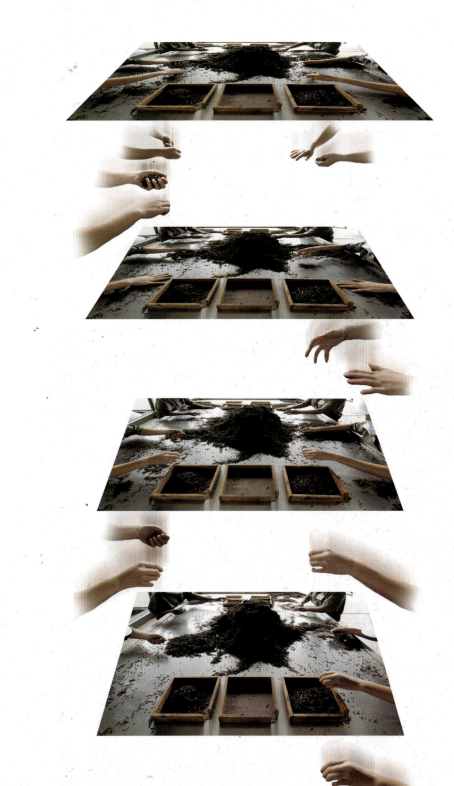

▲ Individual hand positions chosen from the stack and brushed in.

◄ An example of a mountain-water brush scroll painting that defines the style.

▼ Nujiang Valley, China, 2009

COMPOSITE

Tis another class of composites, dodgier on the ethics front than the previous one, setting out to fool the viewer, but with the aim of entertaining and exploring. Advertising is full of clever examples, as is cinema. This is slightly different, and takes as its starting point the vertical Chinese scroll paintings known as "mountain-water." This is a different tradition from Western imagery, in two important ways. First, long and vertical is not part of the European painting canon, and second, the Chinese approach is to express the essence of the landscape, not an image of what can be seen. A common method is to combine elements from the landscape in general and stack them vertically, almost always leading to an upper peak.

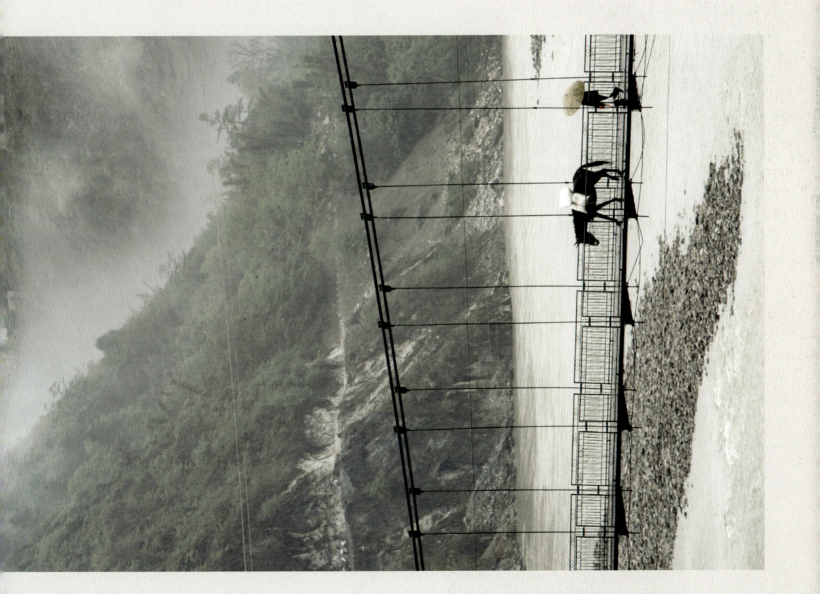

COMPOSITE (CONTINUED)

Shooting in southwest China, in the Nujiang River gorge, I became intrigued with the idea of doing a mountain-water scroll with photography. Could it work? I began with the shot I took of the footbridge and built it upward, using images taken from within an hour or two's drive up and down the gorge. These included the Stone Moon, a striking, huge rock window high above the valley. The combined view is impossible, but like a mountain-water painting it shows more of the essence of this wet river gorge than a single image could. The deconstructed layering shows how it was put together, using a large and soft eraser brush to blend the images.

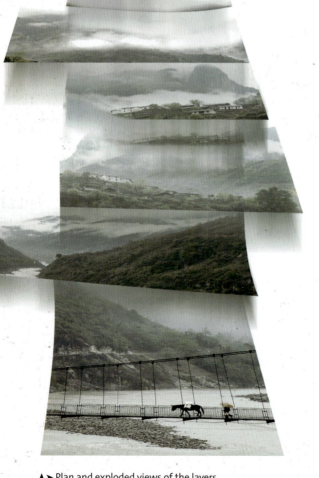

▲▶ Plan and exploded views of the layers.

19335_19.arw

19335_20.arw

19335_21.arw

19335_22.arw

19335_23.arw

19335_24.arw

19335_25.arw

19335_26.arw

19335_27.arw

19335_28.arw

19335_29.arw

19335_30.arw

19335_31.arw

19335_32.arw

19335_33.arw

19335_34.arw

19335_35.arw

19335_36.arw

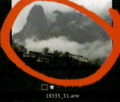
19335_37.arw

19335_38.arw

19335_39.arw

19335_40.arw

19344_18.arw

19344_19.arw

GRAPHIC COMPOSITE

This is more illustration than photograph, which doesn't mean to say that there's anything wrong about it, but that we're in a different world of graphics and layout. It's very much a "declared" work of compositing, not pretending to be anything other than stylized treatment of food, destined for publication somewhere (in fact, in a book). Why bother? Because all of the images in the book were of bowls of noodles, and just as no one wants to eat noodles continuously, we also need a varied visual diet. There are just so many ways to photograph noodle dishes and still show all the ingredients, and it turns out that top-down is very efficient, so I decided to vary the setting, and do it in a consistently graphic way. For this picture, of Char Siu Ramen, I surrounded it with parts of a Japanese box used for serving cold saké in summertime. The mitered joints at the edges of the box made a neat frame when extended, while fading off a downward-looking view made rests for the chopsticks and wooden spoon. Cloning, compositing and fading gave a clean and ordered look that would have been impossible in a straight photograph.

◄ Char Siu Ramen, 1994

◄▲ The different units used to assemble the image.

PRACTICAL COMPOSITE

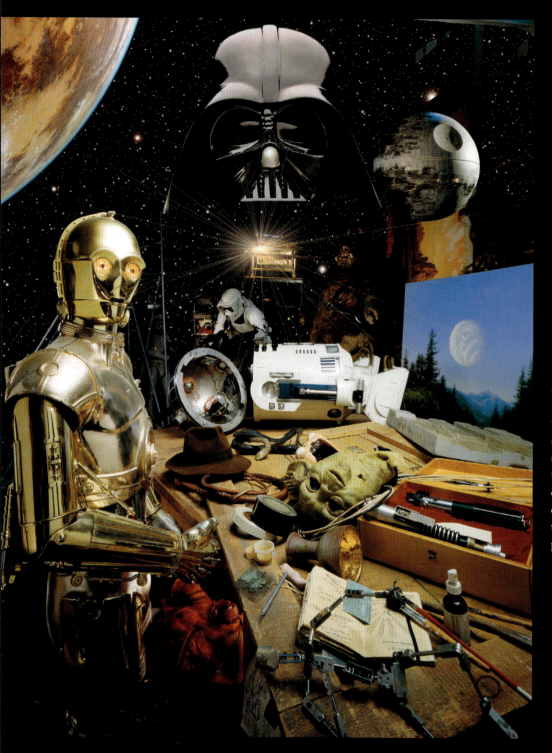

▲ The ILM secret props warehouse, 1990

Sometimes compositing is needed for very basic, practical reasons rather than to try and be clever. Objects may be in different locations (see Frame Break, pages 18–19), or different sizes, or just too unwieldy to haul into position. This was the case here, in the hidden warehouse of Industrial Light and Magic (ILM), the special effects facility set up by George Lucas to create *Star Wars*, and which went on to become the leader in the field. Here was a rare opportunity: to show famous props all together, from *Star Wars* to *Indiana Jones*, and it took an entire day assembling them all in such a way that the frame is packed fully with objects. But the planet at top left (Tatooine) is painted on glass, and the Death Star top right was huge. Also, I wanted Darth Vader looming ominously above. And while we're at it, how about the Ark of the Covenant, which surely needed to be deep in the distance, just as in the closing shots of the movie, with the blinding light trying to escape? Rather than spend another day or two, and sorely try the patience of the crew in building scaffolding and supports, compositing was the way forward. There was also another, smaller reason. This was shot for a magazine story on ILM, and a little conceit of mine was to use, as much as possible, the same kind of special effects techniques that ILM did. Please look at the date below, and you may not be so surprised that the compositing was done entirely in-camera, in pre-Photoshop days.

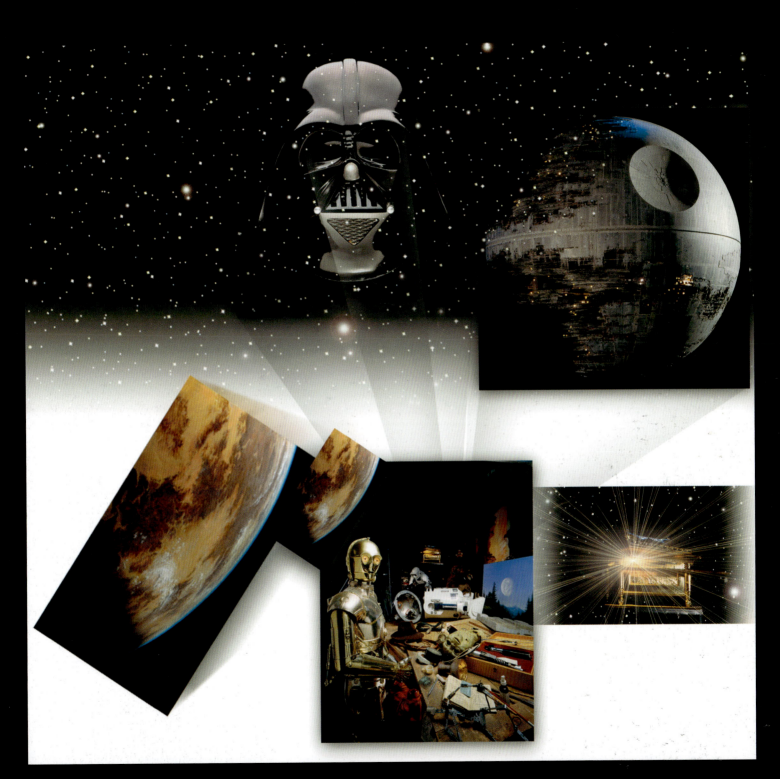

▲ The individual images, ready for compositing.

SEQUENCE

Sequences of action are extremely fascinating, particularly when what is happening is too fast for the eye to take in every detail of movement. In the 1870s and 1880s Eadweard Muybridge made his mark in photography by creating a genre of sequential images to show animals, and later humans, in motion. Slicing up the movement shows us something new in an analytical way, and is the equivalent of selecting frames from a video of the event. This is a Changeable Hawk-Eagle taking off and flying close to the ground at a falconry center; a simple matter to shoot by panning from left to right. An uncomplicated way of showing how the bird flies would be to stack the frames in a strip. But with some more effort, the entire sequence could be turned into a single image, because the set of frames was shot rapidly enough to overlap.

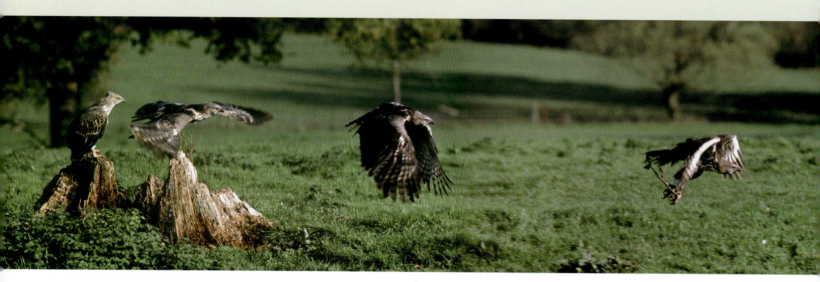

▼ Changeable Hawk-Eagle, Falconry Center,
Gloucestershire, England, 1976

▼▼ The six frames positioned. The irregularities show
it was a handheld sequence.

▲ Forest view, Kensington, London, 2010

INSTALLATION

An installation is a work that occupies a specific space and time, and usually an amount of effort goes into it. Usually, also, the only way of keeping a record of something as temporary as this is to photograph it. So why not use photography in the installation? And of course, make it complicated! The idea, though, is fairly straightforward, suggested by the greenery taking over a corner of the living room. Substitute the view. What made this possible was the coincidence that one of my lightboxes actually fitted the individual frames of the bow window. And that I had a more exotic view in mind than my city street—the Hoh Rainforest in Washington State, photographed on 4x5 transparency film (lots of detail). All I needed to do was to divide it up and make copy transparencies on sheet film to fit the lightboxes.

Oops, did I say one of my lightboxes? Yes, there was only one—I couldn't find any more, so in fact most of the considerable (digital) effort went into making it look real. It truly would have been easier if I had been able to assemble 20 of these lightboxes. Making the power cables fit together and overlap was major, unrewarded work. Digitally speaking, of course, you can't trust any image, or anyone, these days.

▼ Twenty lightboxes in position.

➤ The original view.

➤ Hoh Rainforest, divided.

➤ Placing the first lightbox.

COMBINING 189

INDEX

INDEX